Praise for Laura Cru

"...full of the customary horse fa
ters... [Gail is] a likable heroine reauers—horse lovers or not—
will continue to seek out."

—*Publishers Weekly*

"The work/amateur sleuth/full-time mother conflict is portrayed
very realistically by the author.... The gorgeous descriptions of
the Monterey Bay area and the equine and other assorted ani-
mal population that abound there are wonderfully evocative of
the place. The author is a fourth-generation Santa Cruz County
resident who has owned and trained horses for over thirty years,
and that knowledge is made evident in her writing. An enjoyable
read."

—*Spinetingler Magazine*

"Crum's latest will appeal to her fans and to readers who enjoy
horsey mysteries. Recommended for all public libraries."

—*Library Journal*

"Those who have followed this series know it is as much about
the development of the central character as it is about solving
mysteries.... Gail is more complex as a character and that's why,
like an old friend, we enjoy visiting with her.... Five silver pens
out of five for *Chasing Cans*."

—*Salinas Californian*

"[*Chasing Cans*] is the tenth book in the series, but it stands very
well on its own.... A fast-reading mystery, perfect for an after-
noon's reading, and a touching novel of a mature woman who is
learning her way as a new mother.... A nice read and you'll find
yourself enjoying the people and the location as well."

—*Reviewing the Evidence*

Going, Gone

The Gail McCarthy Mystery Series by Laura Crum

Going, Gone

A GAIL McCARTHY MYSTERY

Laura Crum

PERSEVERANCE PRESS / JOHN DANIEL AND COMPANY
PALO ALTO / McKINLEYVILLE, CALIFORNIA / 2010

A Perseverance Press Book
Published by John Daniel & Company
A division of Daniel & Daniel, Publishers, Inc.
Post Office Box 2790
McKinleyville, California 95519
www.danielpublishing.com/perseverance

Distributed by SCB Distributors (800) 729-6423

Book design by Eric Larson, Studio E Books, Santa Barbara, www.studio-e-books.com
cover design and illustration by Peter Thorpe, www.peterthorpe.net
drawings by Janet Huntington, www.cowhorseart.com

10 9 8 7 6 5 4 3 2 1

LIBRARY OF CONGRESS CATALOGING-IN-PUBLICATION DATA
Crum, Laura.
 Going, gone : a Gail McCarthy mystery / by Laura Crum.
 p. cm.
 ISBN 978-1-880284-98-8 (pbk. : alk. paper)
 1. McCarthy, Gail (Fictitious character)—Fiction. 2. Women veterinarians—Fiction.
 3. Murder—Investigation—Fiction. 4. Sierra Nevada (Calif. and Nev.)—Fiction.
 I. Title.
 PS3553.R76G65 2010
 813'.54—dc22
 2009033493

For Burt, my bay gelding, who won many hearts in his long life, including mine.

And Fergie, my little red dog, with me through good times and hard times, always a trooper.

And for Baxter the cat, who was Zak's friend.

And Toby, Zak's pony, much loved by us all, the magical little white horse who taught my son to ride.

Though death has come between us, love remains.

ACKNOWLEDGMENTS

My thanks to all who have helped with this project:

Jim Warren of the 101, not that anything nefarious ever occurred on his turf.

Deputy Chief Patty Sapone of the Santa Cruz Police Department, for advice on cops and their ways.

Wally Evans and Brian Peters, for assistance with the real horses that provided the models for this story.

Meredith Phillips, my always helpful editor.

Peter Thorpe, for another great cover.

And Janet Huntington, of the *Mugwump Chronicles* blog, who illustrated this book.

Most of all, thanks to Andy and Zak, my husband and son. You were the inspiration for this book, and are the inspiration in my life.

I love you.

AUTHOR'S NOTE

This book is about two real and much-loved places, our pasture in the Sierra Nevada foothills, and the land near our home by California's Monterey Bay. The animals, too, are based on my own critters and are as true to life as my writing skills will permit. This leaves the people and the story, both of which are purely fiction, though my husband and son may have lent a bit of themselves to Blue and Mac. But there is no Carson Valley, no saleyard, no mysterious house in the hills. The character of the "horse blogger" is not based on any real person, but the concept was inspired by the many horse blogs I have read in the past year.

I began this mystery series in 1994 with *Cutter*. The first five books of the series featured the characters of Lonny Peterson and Bret Boncantini, who both subsequently moved away to the foothills of the Sierra Nevada Mountains, and did not appear in the most recent five books. Many readers have asked about these two characters, so I have brought them back in this story.

Thank you to all the readers who have written to me over the years. I appreciate your comments and feedback. For those who would like to learn more about this mystery series, go to www.lauracrum.com.

Happy trails to all.

Laura Crum

Going, Gone

Prologue

THE AUCTIONEER'S rhythm rattled in my brain. Repetitive, almost mechanistic, rapid-fire. "Give me twenty, twenty, twenty, who's got twenty, twenty, twenty, do I have twenty, now twenty-five…"

I sat in the bleachers, high in the shadowy barn above the brightly lit ring where a group of cattle milled. I could see the auctioneer; a slim, dark man in front of a microphone, his mouth constantly moving. The ring men watched the crowd, marking the bids.

What was I doing here?

No answer but the rattle of dirt clods on boards as the ring men moved cattle out the gate to the auctioneer's "Going, gone, sold at twenty cents."

I knew enough to know that the cattle had sold for twenty cents a pound. I still didn't know what I was doing here.

Sudden shrilling noise blasted through my mind; in another minute I was aware of sheets and blankets, my head on a pillow. A dream, just a dream, I told myself groggily. But what could it possibly mean? Why would I dream about a saleyard? Especially an unfamiliar auction. The place in my dream was no place I'd ever been.… I was sure of it.

I closed my eyes as the alarm clock went into its snooze mode, and slowly managed to drift back to sleep. Only to wake moments later, or so it seemed, with my heart pounding.

It's a dream, I told myself, another dream. But somehow I couldn't shake the feeling of dread; it clung to me, as persistent as a toothache. Something was wrong. I could feel it.

The dream didn't seem so terrible when I reviewed it. Just a dark horse, running across a field, under a stormy sky. Not even a horse I recognized. A dark-colored horse, unknown to me. I had the sense that something, either me or the horse, was lost and terrified, and also the feeling of some sort of impending doom. I could not remember what led up to this. If the dream sequence had revealed more than this one scene, it was lost to me now.

Rolling over onto my side, I glanced at the sleeping forms of my husband and son, hearing their gentle, murmured breathing. Nothing wrong there. But something was wrong, somewhere. In this moment, I was sure of it.

I cast about in my mind for the meaning of the fleeing horse, for a clue as to the identity of that horse, an idea about what it might symbolize. Nothing arose. Just the feeling of dread, washing over me in waves, not diminishing.

Was it our trip? We were leaving today on vacation; was this some sort of premonition of disaster? A dark horse as a sign of warning?

Stop it, Gail, I urged myself. Forget it. It was just a dream. But even as I rolled over and tried to grab a few more minutes of sleep, I felt an uncomfortable certainty that the dream had meant something. What, I wasn't sure.

Chapter 1

THE DIESEL engine of the four-wheel-drive pickup chugged rhythmically as a heartbeat; my hands on the steering wheel registered its steady pulse as automatically as I was aware of my own. A glance in the rearview mirror showed me that the horse trailer was tracking along evenly behind the truck, its three passengers riding quietly. Above my head, in the cab-over camper, my husband, Blue, and my six-year-old son, Mac, were dozing, or perhaps wrestling, judging by the occasional thumps and bumps.

Loosening my grip on the steering wheel, I stretched out each hand in turn, squinting a little at the view through the windshield. Flat green alfalfa fields, dusty gray-brown dairies, miles and miles of almond orchards and grapevines slipped by outside the truck. California's Central Valley looked tranquil in the late afternoon sunlight, as simple and unadorned as a country girl before the era of TV. We were on our way, at last.

After much planning and preparation, our small family, complete with mounts, was embarked on a vacation in the Sierra Nevada foothills. Or perhaps it would be more accurate to say that we were off to visit my old boyfriend, Lonny Peterson, at his ranch near the small town of Carson Valley. Even more accurately, to visit my two horses, Danny and Twister, both of whom

were currently turned out in the pasture there. Whichever way you cared to look at it, I thought with an inward smile, we were going to spend some time living in our camper, riding horseback through the April green grass of the foothills, swimming in the creek, and picnicking in the wildflowers. What could be finer?

It wasn't that I didn't love my home in the hills near Monterey Bay, on California's central coast. I did; I loved my garden and animals and my life as a homeschooling mom. But I loved the Sierra Nevada foothills, too, and I was ready for a change of pace.

How in the world had this all come about? I let my mind drift back over the events of the last few years, even while my eyes stayed resolutely on the road. Six, no seven years ago, I had been Gail McCarthy the horse vet, wedded to my career, having taken only three vacations in my ten years as a practicing veterinarian. Then had come marriage to Blue and the birth of Mac, and hey presto, suddenly I was a stay-at-home mom, raising my baby.

Vacations had remained rare; besides my child, I had horses, dogs, cats, chickens, and a large garden to care for. Such things are not easily left, even for a short time. And Blue was equally tied down, busy with his work as a manager and plant breeder at a rose-growing farm. In short, we stayed home on our own small farm and enjoyed it.

A sudden metallic jingle startled me. The dog sitting on the passenger seat shook her head again, causing her tags to rattle musically.

"Hi, Freckles," I murmured, stretching out my hand to stroke her head.

Freckles wagged her tail and flattened her ears; her light blue eyes gazed up at me in a mildly worried way. Last month she'd lost her longtime canine companion, my Queensland Heeler, Roey, and she was still moping.

So was I, for that matter. Roey had been with me eleven years; I'd raised her from a pup, and losing her left a gap I could not get used to. I still expected her presence by my side, as the

tongue expects a familiar tooth in its place and cannot accustom itself to the empty hole. Over and over again I found myself looking for Roey, only to be reminded, once more, that her body lay buried in our garden, next to the pond.

I imagined that Freckles felt much the same. At any rate, her usually lively personality seemed flattened, and her somewhat comical appearance—a cross between a Jack Russell terrier and an Australian Shepherd, Freckles was anything but ordinary—was dimmed. Freckles looked sad and worried.

"I miss her, too," I said quietly, and the little rough-coated, liver-and-white spotted dog wagged the tip of her tail and pushed her whiskery muzzle up against my arm.

I patted Freckles' head and thought of Roey, who should have been lying in her accustomed place on the passenger-side floor. Ready tears rose to my eyes and I blinked. The pain of losing my dog wasn't rendered any easier by the fact that eleven wasn't particularly old for a Queensland, and Roey might have been with me much longer had she not been visited with degenerative myelopathy, a spinal disease that caused a gradually worsening paralysis. My bouncy little red dog had slowly been reduced to shuffling and then stumbling and was finally unable to walk at all. Fortunately the disease caused no pain, and Roey, always a trooper, had remained bright-eyed and reasonably cheerful through it all.

Blue and I had done our best to stay the course with her; we'd bought her a canine "wheelchair" and pushed her about in her little cart for several years, until she grew too weak to bear it; we'd dealt with her worsening incontinence as patiently as we could, though neither of us had expected to have a dog in diapers after our child had finally outgrown them; we'd taken her on our occasional overnight camping trips, which she loved. For the last year I'd given her a daily dose of painkillers and antibiotics, to combat her worsening arthritis and constant bladder infections. But neither of us could bear the increasing look of stoic misery in

her eyes, and when she started to develop large sores on her legs that would not heal, we knew it was time.

Still, I'd put off the inevitable day with endless excuses— Roey still enjoyed treats and being petted; she licked Mac's ankles affectionately whenever he came within reach; she played with her own front paws—nipping and mock "wrestling" with herself; she wasn't ready to go. In the end, I wasn't sure if I was prolonging her life for her sake or mine. She'd been with me so long, taken me through so much; she was part of our little family. I couldn't picture my life without her.

It was the shocked look on the face of a friend who was a small-animal vet when he saw her that convinced me we'd gone far enough. Roey's poor, frail body was literally rotting away, and her eyes, though still bright, were perennially anxious. She was ready to go.

I sighed and blinked again, feeling the tears run down my cheeks. Swiping them away with one hand, I put my focus back on the road. Roey was gone, though perhaps her spirit rode with me. I couldn't know. The trip was ahead of me. I, too, would let go.

Maybe it was the loss of my dog that had precipitated this trip; I didn't really know that for sure, either. All I could speak to was the urge for a change that had come over me suddenly. I had asked, no, demanded, that Blue finally take a real vacation from work, and to my own surprise, I'd gone out and bought a self-contained camper for our pickup truck. And here we were, on the road.

A long, straight stretch of road, at the moment. But up ahead were the rounded green slopes of the foothills, and beyond that the deep blue ridgeline of the Sierra Nevada Mountains, crowned with white. The Sierra Nevada, the range of light. John Muir had said that. I smiled. We'd be at Lonny's ranch in an hour.

A thump from the horse trailer made me glance in the mirrors. Nothing obviously wrong—no doubt one of the inmates had kicked at the sides. Plumber, probably. My little brown horse

had a habit of doing that. Gunner, the big bay, and Henry, Mac's horse, would inevitably be riding quietly and patiently, as was their way.

The logistics of getting an expedition like this organized had seemed mind-boggling to me when I'd started. It had been a chance comment of Lonny's that had shown me the way, opened a door to the possibility.

"The hills are beautiful in the spring," he'd said. "You should really come and see it. It's horse heaven up here. And there's a swimming hole in the creek that your kid would love. It'll be perfect in late April."

That had been a month ago, right after we'd buried Roey. I'd called Lonny to check on my two turned-out horses and suddenly conceived of this idea. Lonny had convinced me that he had a perfect campsite for us—along the creek, completely private, corrals nearby—and that we—and our horses and dog—would be no trouble to him. And now, in the last week in April, after a month of preparation, we were on our way.

Motion in the rearview mirror caught my eye. I looked back and saw Blue peering at me from the camper window.

"Do you want me to stop?" I called back.

"We're ready to come up there with you," he answered.

"Okay. I'll pull over as soon as I can."

Moving from the camper to the cab demanded a stop, at least for Blue and me. Mac and Freckles were the only ones who could squeeze through the small window connecting the truck and camper.

A convenient off-ramp presented itself and I pulled off the highway. We were just east of the town of Merced, or so I reckoned. All around us the hills were rising up, their slopes brilliantly green and spangled with wildflowers. The "bald hills," if I remembered right. That's what Lonny had called them.

I eased the truck and trailer to a stop, careful not to jostle any of the passengers. Once we were safely parked, I clipped a leash

on Freckles and let her out for a brief walk on the shoulder of the road. Blue and Mac emerged from the back of the camper and we all stretched in the spring sunshine. A little wind ruffled through my hair and Blue smiled at me.

"Can you watch Mac?" he asked. "I'll go back and check on the horses."

"Sure," I said, and then to Mac, "Come here, baby."

This automatic endearment was met with a glare. "I'm not a baby," my little boy said firmly.

"No, I know you're not," I amended. "Sorry."

"And why do I have to come over there?"

"You don't, I guess. Just stay off the road."

"I will. Can I walk Freckles?"

"Sure." I smiled and handed over the leash.

At six years old, my son was becoming increasingly independent; I was reminded over and over again that I no longer had a baby. That part of my life was gone, Blue and I having decided that one child was just right for us. And I was forty-five, after all. It wasn't likely that I'd conceive another.

I felt a sharp pang as I watched Mac tug at Freckles, who was never quite sure that Mac was the boss. Like me, she'd known him since he was a wiggling pink newborn in my arms; it was hard to come to grips with the strong-minded individual he seemed to have become so suddenly. Only yesterday he'd been a fluffy-headed toddler, surely. And yet it wasn't sudden at all. A steady progression from my arms to his own two feet, on which he now stood firmly, a six-year-old boy determined that he was in charge of a little spotted dog.

Freckles yielded to another tug and followed Mac along the shoulder of the road. Blue reappeared from the back of the horse trailer and reported, "Everybody looks fine."

"Good," I said. "Shall we get going?"

"Yep," Blue agreed. "It would be nice to have a little time to set up camp before we barbecue."

"We ought to get there just before five o'clock, if everything keeps going smoothly."

Blue grinned. "God willing and the creeks don't rise, right?"

"Right," I said and called, "Come on, Mac, bring Freckles back. Let's get going."

"Okay, Mama." Obediently my somewhat unpredictable child half led, half drug his recalcitrant dog back in our direction, having suddenly decided to be cooperative.

"Will Lonny be there when we get there?" Mac asked, as we all climbed in the big cab of the four-door diesel pickup.

"He said he would," I told Mac.

Mac had met Lonny once and was quite impressed by him, I wasn't exactly sure why. A big, rough-hewn man nearing sixty, with a soft western twang in his voice, a friendly smile, and steady good-humored green eyes, Lonny had a faintly John Wayne-esque aura. Certainly he was a team roper and ran his own little horse ranch, but since we had horses, too, and Mac's father was a more than competent horse trainer, I didn't think Lonny's cowboy aspect was enough to imbue him with glamour in my son's eyes. Whatever it was, Mac had never forgotten Lonny.

Blue met my glance above Mac's head and his lips twitched humorously. Knowing that he was about to make some quip about "your old cowboy boyfriend," I forestalled it by saying, "Don't worry, Mac, if Lonny's not there when we get there, he told us exactly where to camp, so we know where to go."

"Will we see Danny and Twister?" Mac asked.

"Of course we will. They're turned out with Lonny's horses and we'll be camping right in the field where they're living, so we're sure to see them soon."

"Hope they don't chew up our brand new camper," Blue muttered.

"Lonny said there was a fence around the campsite, to keep the horses out. And there are four little corrals next to the old water trough, which is right by the creek. It should be just perfect."

"Right," Blue said, and smiled at me.

Without thinking, I'd climbed into the passenger side of the truck; Blue was now driving, having complied with my unspoken request. Mac and Freckles had assumed their usual positions in the back seat.

"You'll need to be my navigator." Blue pulled back onto the highway, his eyes moving from the road ahead to the rearview mirror and back again. "I've only been there once, when we dropped the horses off. I'm not sure I remember how to get there."

"Will we get lost?" The quick worry in Mac's voice was familiar and another sign of his growing age and independence. Gone was the toddling child who trusted our judgment implicitly. This new six-year-old boy questioned our thinking, double-checked our decisions, and had lots of his own ideas.

"Don't worry, sweetheart; I know how to get there," I reassured him. "We won't get lost."

Mac subsided back into the seat, gazing out his window curiously at the tapestry of rolling hills, dotted with cattle and backed by snow-capped peaks. Or po-capped sneaks, as Blue was wont to say. My husband had a knack for playing with language.

I glanced over at him affectionately as he drove, his blue-gray eyes steady on the road. Seven years of marriage had endeared Blue to me in ways that I'd never imagined. I loved every inch of his six-and-a-half feet, from the long red-gold curls now confined in a ponytail, to the equally long, slender feet, currently encased in leather cowboy boots. Blue was, as they say, a good catch.

"Turn right here," I said, pointing to a road sign ahead that said OLD HIGHWAY.

Blue complied and the diesel truck, with its loaded camper and trailer, chugged up a long grade with a deep gully running down one side. At the bottom of this canyon a creek leaped and splashed, falling between granite-walled pools that looked perfect for dipping.

"That's the creek that runs through Lonny's property." I

gestured to Blue and Mac. "He says there's a great swimming hole not too far from our campsite."

"Pretty," Blue commented, glancing down, and then returned his eyes to the road.

"What do you think, sweetie?" I looked back at Mac, who was peering out the window.

"Can I float in my inner tube?" he asked. Mac's swimming was still a little sketchy.

"Sure you can," I said. "I'll float along with you. I love doing that."

I could feel the engine working as the truck persisted up the hill, tugging its cargo.

"Not too far now," I said to Mac.

The canyon opened out into a broad valley, wide meadows studded with oak trees and big granite outcroppings. The Old Highway skirted one side of this valley while the creek meandered down the middle.

"Right there, that little hill at the head of the valley, that's Lonny's place." I pointed and saw Mac's eyes follow my hand.

On we went, following the valley as it narrowed; just as the road started back up into the hills, a green metal ranch gate on the left bore the name LONNY PETERSON.

"There," I said, unnecessarily.

Blue pulled off the road and stopped, while I got out to open the gate and close it behind us. Then we were bumping down the gravel ranch road, everyone, including Freckles, craning to see out the windows.

Brilliantly green fields rolled away on all sides of us, spangled with the snowy white flowers called milkmaids and violet-blue patches of lupines. We could see the creek on our left, and the small hill that crowned the valley on our right. Ahead of us, the road forked.

"Lonny said to take the left-hand fork," I told Blue. "It leads to the campsite. The right-hand fork leads to his house."

"Right," said Blue, and bore left.

In another moment, as we rounded the shoulder of the hill, our camp came into view. I smiled; Blue did, too. Mac's mouth formed a perfect "O."

"Oh Mama," he said, almost trilling with excitement, "it's perfect."

And it was.

Chapter 2

WE WERE HERE. In camp at last. Next to the creek, in the shade of some big oak trees, was a set of corrals and a large concrete water trough that looked as if it dated from the turn of the century. About a hundred feet away, a small grove of young oaks was fenced in; a wooden table and chairs and a stone firepit indicated that this was the campsite. Blue pulled the truck and trailer up next to the corrals and turned off the engine.

Before you could say "boo," we'd all scrambled out of the truck and were looking around. It was amazingly green. Vividly, splendidly green, bright in the spring sunshine, a silken meadow of grass spread out before us with the creek carving a silvery, reflective serpentine through it. Even the air smelled green.

I took a deep breath and detected an herbally aromatic undertone of cilantro beneath the sweeter scents of clover and wildflowers.

"Wow," I said. "Is this ever pretty."

"It is," Blue agreed. "Should we unload the horses?"

"Sure."

I glanced over one shoulder. Mac and Freckles were already down by the creek, throwing stones and having a drink, respectively. Since the water appeared to be only a foot or two deep

here, I decided that Mac could be left to his own devices, as long as he remained visible. Following Blue to the back of the trailer, I helped him to unload the three geldings and put them in corrals.

First out was cocoa brown Plumber, still spry, lively and sound at seventeen years of age. He nickered at me as I grabbed his lead rope; Plumber was a talker. Next big bay Gunner, with his high white socks, blaze, and one blue eye. Gunner was seventeen also, but he hadn't aged as well as Plumber. His back was slightly swayed and he backed off the trailer stiffly, victim of several arthritic and degenerative complaints. I had gotten Lonny's permission to turn him out in the pasture, to see if the greater movement and freedom would improve his level of soundness. Gunner led off willingly to his corral; I didn't plan to turn him out until he'd gotten used to the place.

As I latched Gunner's gate, Blue led Mac's horse, Henry, into the third corral. Henry was twenty years old, a bright copper-red sorrel with a white stripe down his face. Despite his age he was perfectly sound and a well-broke, bomb-proof riding horse for Mac. I'd purchased him a year ago from my friend, rancher Glen Bennet, after Mac's pony, Toby, had died of cancer. Henry was an old team roping horse who had seen and done it all; nothing bothered him. He marched into his new corral nonchalantly and immediately began cropping grass. Just another place, his demeanor seemed to say.

Watching Henry grazing calmly, Gunner and Plumber, who were both pretty wide-eyed, visibly relaxed, and, following suit, dropped their heads to the grass. It had been many years since either of them had been hauled much.

"There's enough grass there to keep them busy for a while," Blue commented. "Shall we get the camp set up?"

"Sure." Once again I cast a reflexive glance at Mac, who was still chucking stones in the creek, Freckles at his side. No problem there, though Mac's pants were now wet to the knee, and Freckles' white belly was dark brown with mud.

I smiled and walked over to the campsite while Blue un-hitched the horse trailer, then swung the gate open so that he could back the camper into the site. Once it was situated and leveled to his satisfaction, I shut the gate and Blue began the process of making camp. I wandered on down to the creek.

Splashes and happy shouts and barks from Mac and Freck-les, who were romping about in the water. A yellow-breasted bird trilled musically across the grass—a meadowlark. Sun-beams slanted through the gold-green new leaves of the oak tree branches above me. The aromatic cilantro fragrance wafted up from under my feet. Peering down, I spotted the fringed, dark green leaves of what looked like the wild herb.

Looking up, I stared at a massive gray granite outcropping on the other side of the creek, like a castle sleeping in the sun. In all directions the hills rolled and rippled away from me, marked with oak trees and upthrusting clumps of monolithic boulders in a sea of waving grass. I took a deep breath.

Suddenly Mac called, "Mama!"

I jumped and whirled, my maternal instincts on the look-out for problems, but Mac was smiling. My eyes followed his pointing finger; a small band of horses was moving across the far field in our direction, led by a steel gray horse who was gallop-ing flat-out, rapidly outdistancing his comrades. My son and I stared, riveted, as the horse raced across the field toward us. We could hear and feel the earth rumble to the driving hoofbeats, see the horse's black mane and tail flying wildly in the wind as he drew nearer. Mac's eyes were wide, his lips slightly parted. The running horse's head and tail flew up as he came closer, and he slowed and snorted out long, rolling snorts, his gaze fixed in our general direction.

"What in the world is with him?" I said out loud, and looked over my shoulder to try and figure out what this horse had seen to get him so excited.

Blue was just climbing down the ladder from the roof of the

camper, and I realized that the horse had probably never seen an RV before. Sure enough, the shiny steel gray gelding pulled up right in front of the campsite, puffing and blowing with excitement, prancing and high-stepping, head and tail thrown up in the air, his gaze fixed on the large white camper. On close inspection, he proved to be a blue roan.

"That must be Smoky," I told Mac. "Lonny's new colt."

"He looks like Smoky the Cowhorse," Mac said softly. I had been reading him the Will James book for the last few months.

"He does," I agreed. "He doesn't have the blaze and white socks. But he's that slick mouse gray color. Maybe Lonny named him after Smoky the Cowhorse."

Plumber and Henry both nickered shrilly; Gunner echoed them with his deeper *huh huh huh*. Smoky neighed a response, kicked both back feet high in the air in a show of exuberance, and whirled to gallop back to his herd. These four horses, following more sedately behind the colt, proved to be dappled gray Twister; two bays, one of which was Danny and one Lonny's horse Chester, looking like twins from a distance (they were full brothers); and a little bright gold palomino that I didn't recognize.

"There's Twister and Danny!" Mac's voice was excited.

These two horses, retired to the pasture because of injuries that had made them unusable as riding horses, had been part of our life for many years, living in our neighbor's ten-acre field. When she had died a year ago, Lonny had offered to keep them here. Though I'd been sad to have the horses so far away, I'd accepted the offer with alacrity, as I knew Twister and Danny would be far happier turned out than standing around in corrals, even my big corrals.

Looking at them now, I was aware that I'd made the right choice. Both were shiny, bright-eyed, and healthy, and though Twister walked with a slight limp, and Danny's breathing was labored, the results of their respective injuries, they both looked quite content.

Mac was anxious to pet them, but the resident horse herd was far too excited for that, milling about the corrals greeting the newcomers, nickering and squealing. The roan colt did twice as much running around as anyone else. Mac and I watched their antics, as Blue strolled up to us.

"So the one bay, the blue roan, and the palomino must be Lonny's," Blue said, his eyes on the horses.

"Must be. The bay is Chester. Glen Bennet raised him; he's a full brother to Danny. He's Lonny's team roping horse. The roan is a four-year-old colt Lonny just bought; I think he calls him Smoky. I don't know what the palomino is; he never mentioned him. He's cute, though."

"Little," was all Blue said. At six and a half feet tall, Blue preferred to ride horses that were well over fifteen hands, and the palomino gelding looked to be about fourteen three, hardly bigger than a large pony. The exact height of Mac's horse, Henry.

"Just right," I said. At forty-five years I was definitely feeling a

bit stout and middle-aged and the shorter a horse was, the better I liked him. "I think Henry's the perfect height; I can get on and off him without tweaking myself. Even Plumber seems too tall, anymore."

"Plumber's only fifteen one," Blue said dryly.

I laughed. "Yes, I know. I'm turning into a lazy old lady. Mamahood has not been good for my figure or my athletic abilities."

Blue put his arm around me and dropped a kiss on my hair. "I think mamahood becomes you," he said.

Mac's sharp little eyes were now fixed on this exchange.

Blue grinned at his son. "We think Mama's perfect just the way she is, don't we?"

Mac nodded emphatically. "We love you, Mama."

I smiled. One of the delights of my life was the unequivocal way in which my child regarded me—center of his universe, brightest star in his sky. No matter how annoyed he got, or I got, from time to time, the bottom line of his world was "mama." I knew it wouldn't last forever; I was darned sure going to revel in it while it persisted.

"Well, what now?" Blue asked me. "Ready to sit down with a margarita in hand?"

"I sure am." I took a deep breath. "I'm happy just to be here. Let's go have some juice and tortilla chips, Mac."

"Okay." Mac was still watching the horses mill and squeal. "Will Henry be all right?"

"Sure he will. The horses are just saying hi. Henry's an old hand. Nothing bothers him." I said it with conviction.

Mac's gaze rested on his horse, who had gone back to grazing, and he smiled. "Where's Lonny?" he wanted to know.

"I'm not sure," I answered. "But he'll be around. He said he would."

The three of us filed into the campsite, Freckles at our heels, and shut the gate behind us to keep the horse herd out. Blue climbed into the camper to make margaritas. I handed Mac an

apple juice in a box and a bag of tortilla chips and sat down in one of the sturdy wooden chairs. From here I could look down on the creek, sparkling away through the meadow, and watch the bright shapes of the horses, who were drifting over to the old water trough to drink. We were shaded by the little grove of oaks that stood in the campsite and fanned by a breeze that seemed to flicker along the creekbed. What could be better?

Margaritas, of course. Blue brought these out of the camper and I accepted one gratefully. I had just taken the first sip when movement in my peripheral vision caused me to turn my head. A vehicle was approaching down the two ruts that formed the ranch road. Not Lonny's pickup. A medium-sized dark sedan. Not a car I recognized. It had an oddly official look, even in the distance.

As the car bumped up the road toward us, I saw Blue stare at it and narrow his eyes. "That looks like some kind of police car," he said at last.

"It does," I agreed.

Mac glanced excitedly in this direction. Freckles barked a warning; I told her to lie down. She complied reluctantly, still woofing, and we all watched the car approach.

The dark sedan with some sort of insignia on its side bumped to a halt in front of our campsite. There was a long pause, as if the people inside were conferring. I couldn't see much through the tinted windows, but there appeared to be two men in the front seat.

Simultaneously the driver and passenger doors opened and two figures climbed out. The one on the passenger side was undoubtedly Lonny, though looking a great deal more old and tired than I remembered him. The one on the driver's side... I stared. He wore a beige uniform, his hair was gray, the lines around his eyes were unfamiliar, but surely...

My mouth opened like a cartoon character. "Bret?" I said disbelievingly. "Bret Boncantini?"

The guy in the uniform grinned, and in that three-cornered smile showing crooked teeth, I unmistakably recognized my childhood friend. I hadn't seen him in over ten years. "It's Gail," I said, smiling back at him. "Gail McCarthy." "I know," Bret said. "Lonny told me you were here." I shook my head in amazement. Bret Boncantini was a piece of my past. We'd grown up together on neighboring ranches in Santa Cruz County, and our friendship had sprung back up when I returned to my hometown to take my first job as a practicing vet. Then, twelve years ago, Bret had married his current girlfriend and moved to the Sierra Nevada foothills...near here. The last I'd heard of him, he was working as a cowboy and had two kids.

He and Lonny both walked forward to the campsite and Blue and I advanced to the fence, Mac and Freckles behind us. Freckles wagged her tail; Mac stood close to my side.

"This is my husband, Blue Winter," I said, "and Mac, my son. McCarthy Winter."

Bret and Blue shook hands through the fence, looking oddly like a prisoner greeting a visitor to a jail cell.

"Come on in and sit down," I said, and then glanced at Lonny. "I mean, it's your place, of course."

Lonny gave me a faint vestige of his old smile, his face more tired and worn than a beat-up saddle. "Can't, I'm afraid," he said.

"Can't what?" I was feeling more confused by the minute.

"Can't sit down."

"Why not?" I knew I sounded inane; I just couldn't seem to get the hang of this conversation.

Lonny and Bret looked at each other. Then Lonny looked back at me and met my eyes. "Bret, here, is in the process of arresting me. I'm not going to be able to visit."

"Arresting you? Bret? But why? Are you a cop?" I fired this last question at Bret in disbelief. A cop was the last thing I'd

ever thought Bret Boncantini might become. As a young man, his playful, irreverent spirit had seemed far more suited to the role of a legendary cat burglar than a cop.

"Yep, I am a cop. A deputy sheriff of Martindale County. I was hired three years ago, to be exact." Bret's expression was a little rueful. "And right now I've got the unpleasant duty of escorting Lonny, here, to jail."

"But why?" I demanded again. "What's happened?"

Once more, Lonny and Bret looked at each other. Bret shrugged.

Lonny answered the unspoken comment. "You're going to have to know." His eyes were sad. "I'm being charged with the murder of my girlfriend."

"What?" My voice had risen to a shriek.

"And her brother," Lonny added.

"No way. You can't be. What happened?" I knew I was babbling; I was aware of Blue's shocked silence next to me. Mac reached for my hand.

"I didn't do it, Gail," Lonny said, still meeting my eyes.

"I never thought you did. But why are they arresting you?"

Bret answered this question. "John Green, the detective, likes him for it. I can't tell you why right now."

I stared at Bret. "You're arresting Lonny?"

"It's my job, Gail. Lonny understands. I don't think he did it, either. Don't tell John I said that," he added to Lonny.

Lonny shook his head. "I don't suppose it will make much difference either way." He turned back to me. "I'd appreciate it if you guys would keep an eye on the horses until I get back. Oh, and that palomino's for you, Gail, if you want him. It's a long story and I don't have time to tell it now. Go ahead and ride him; he's gentle. I remember you said that Gunner was sore. If you want to know more about Sunny, ask my neighbor, Kate. She's right across the dirt road from my house." Lonny turned back to Bret. "Let's get it over with."

Bret looked at me and then at Blue. Our faces must have mirrored the shock we were feeling because Bret gave us a sympathetic half smile. "I'll come back as soon as I can," he said. "Tell you a little more."

"Thanks," said Blue.

I was wordless.

And we all watched Lonny and Bret climb in the sheriff's car and drive slowly away.

Chapter 3

"MY GOD," I said. Sinking down in my chair, I took a long swallow of margarita. The evening didn't look quite so pretty now. "I don't believe it."

"It is a little hard to believe," Blue agreed.

"Lonny's being arrested for the murder of his girlfriend and her brother. I didn't even know he had a girlfriend," I added inconsequentially.

"And that sheriff's deputy is your old childhood friend." Blue shook his head.

"I knew he'd moved to this part of the world, but I had no idea he'd become a cop. My God," I said again. "Bret, a cop. I don't believe it."

"Mama, what's going on?" Mac's large blue-gray-green eyes were worried.

I looked down at my child, uncertain what to say. "Everything's all right, baby," was what came out of my mouth. "I don't really know what's going on, but we're fine, our horses are fine, Freckles is fine. It'll all be okay."

"Is Lonny okay?" Mac demanded.

How to answer this? "I'm sure he'll be okay," I said reassuringly. "We'll see him soon." But I wasn't at all positive about this.

I had no real idea what the protocol was when you were arrested for murder. Thankfully this had never happened to me.

"Will they let him out on bail?" I asked Blue.

"It depends."

Blue sounded confident, as if he knew something about this sort of situation. I decided not to ask him how he knew. Blue's checkered past included jail time in Bali and studying with the senior tutor of the Dalai Lama. He knew lots of things I didn't.

"What would it depend on?" I asked him.

"Mostly how the sheriff-coroner feels about him. In these small towns, everybody knows everybody else. Unless the sheriff has a grudge against Lonny, he'll probably set bail, though with a serious crime like this, he might not. But Lonny's a solid citizen and a property owner. I'd guess that he'll be able to get out on bail. It'll be high, though."

"What's high?"

"Maybe a million." Blue shrugged. "He'll need to come up with ten percent cash. Most people mortgage their property."

"Oh," I said.

"That's if the sheriff decides to set bail. He'll only do it if he's confident Lonny's not the type to bolt. For sure Lonny won't be allowed to leave the county."

"Oh," I said again. "How soon might he get out?"

"If they set bail, it will be when he's formally charged. Usually that's seventy-two hours after the person is brought in. So he could be out in three days. Wednesday, maybe."

I took another swallow of my drink. "How do you know all this stuff?" I demanded, curiosity overcoming caution.

Blue shrugged. Curiosity wasn't going to get me anywhere.

I took another drink and rested my eyes on the sun, which was hovering above the western ridge, its rays slanting between the branches of the oaks, which were just leafing out. If it hadn't been for the drama we had recently witnessed, it would have been an idyllic moment.

As it was, my mind chased in circles, trying to imagine any scenario that could have led to Lonny being accused of murdering his girlfriend and her brother. Since I had no information to go on, this was fruitless.

My eyes drifted to the horses, who were fanning out across the meadow, grazing. The palomino was for me? What on earth had Lonny meant? I hadn't asked him for a horse, merely mentioned that Gunner had been sore off and on and I'd like to try turning him out.

I stared at the little palomino gelding. He was thick-bodied and a bit coarse, something like an overgrown pony, but very appealing. His dappled gold color, cream white mane and tail, and cute head with a neat white stripe between big brown eyes didn't hurt. And he looked reasonably well made overall. But what had possessed Lonny to buy me a horse without asking me? Like most people, I tended to want to pick out my own horses.

Blue's voice interrupted my musing. "Let's go gather some firewood."

Blue was talking to Mac, but I obediently got up and followed them down toward the creek bed, where we scavenged dead limbs from the oak trees. A couple of trips and we managed to drag up enough wood to create a sizable pile by the stone firepit.

Blue and Mac began breaking the branches into appropriate lengths for the fire, to Mac's great enjoyment. I watched them banging the branches on big rocks, with loud, satisfying "cracks," and sank back in my chair, margarita glass in hand.

The horse herd had drifted off and were distant dots in the meadow now. The sun was below the western ridge and the sky above the horizon had turned vaguely apricot. Our three saddle horses seemed settled in their corrals; Henry had quit grazing, as if he were full. The other two still had their heads down.

"I'm going to water the horses and give them a little hay," I told Blue.

"Good. Mac and I will build the fire."

Leaving them to their intricate construction of twigs and small sticks, I headed for the horse corrals, halter in hand. One by one I caught the geldings, led them to the water trough, and let them drink their fill. Then I distributed small flakes of alfalfa; they'd eaten quite a bit of grass already.

Eventually I just stood, leaning on Gunner's corral fence, my mind drifting as I watched my big bay horse eat. I'd owned Gunner since he was three; he'd been my friend and companion through many, many adventures. Was I really ready to turn him out here? Would Lonny even be around to take care of him?

My mind jumped back to Lonny with a vengeance. I'd known Lonny almost as long as I'd owned Gunner. And I simply couldn't imagine any scenario that would lead to him killing his girlfriend and her brother. I'd been Lonny's girlfriend at one time, so surely my opinion on this subject was worth something. Hell, I trusted Lonny. I trusted him with my horses; I'd trusted him completely when I'd been with him. Like all human beings, he had his faults, but murder his girlfriend? No way.

Once again, I wondered just who his girlfriend had been. He certainly hadn't mentioned her to me. But then, Lonny had never been known for chatting about his personal affairs.

Restless as a pinball bouncing from flipper to flipper, my brain leaped from thought to thought, collecting what I knew about Lonny and adding it up. A horse packer in these very mountains for many years, Lonny had eventually bought the pack station he worked for and grown rich enough to retire. Back when I'd met him he'd been living on the California coast and was recently separated from his wife. We'd dated for many years, or whatever the term was. We'd never moved in together, and when Lonny had decided to move back to the Sierra Nevada foothills, I'd elected to remain in my home. Our romantic relationship had come to an end, but we'd remained friends. And at no point in this long progression had Lonny ever been anything but a kind,

decent person. I absolutely did not believe that Lonny had murdered anyone.

Glancing over my shoulder, I saw that Blue and Mac had the fire leaping high in the firepit; flickering orange-gold tongues rose into the air above the gray rocks. Fortunately, in green-grass season, sparks were no threat, and the fire seemed to be burning cleanly, anyway. I headed in their direction.

As I once again settled into my chair, facing the bright, dancing flames, Blue reached for my margarita glass.

"Can I make you another?"

"Sure."

I edged my chair a little further back from the fire. The evening was still pleasantly balmy, though I could feel a chill gathering. By nightfall the fire's warmth would be very welcome. But in this soft April gloaming, with spring peepers singing madly down by the creek, I didn't feel the need to be toasted.

Mac, on the other hand, stood as close to the fire as he could stand, his nose wrinkled slightly as he took in the flickering, flashing tongues of flame, licking and lashing at the constantly shifting pile of sticks and twigs. In another moment the breeze shifted and Mac blinked, coughed, and moved rapidly away.

"Smoke," he protested, rubbing his eyes.

"Yep, it does that," I agreed, accepting my refilled margarita glass from Blue and scooting my chair a few feet to the left. "You've got to keep moving."

"Smoke follows beauty, you know." Blue smiled at me and poked the fire with a long stick.

"So how come it's following me?" Mac grumbled.

We all laughed. I forbore to remark that Mac was, indeed, beautiful, a comment I didn't think he'd appreciate. But I never got enough of looking at my tall, slender young son, with his long legs and graceful hands, so like his father's. His face didn't really resemble either of us much—big blue-gray-green eyes, a loose cap of ruffled fawn-colored hair. A strong chin, gentle bow of

a mouth, a round forehead. Mac looked like nothing so much as those ethereal paintings of fairies or angels so popular in the early twentieth century; again, not something he would care to hear me say.

Blue climbed back into the camper and emerged with a platter of steaks. After poking the fire into the required bed of coals, he popped the grill on top of it and forked the steaks into position. Mac watched every move.

Getting to my feet, I climbed into the camper to do my part of the evening chores. In the tiny kitchen, I got out French rolls and began buttering them and wrapping them in tin foil. Once these were beside the fire, I started to make a salad. Through the small window in front of me, I could see the wide expanse of the meadow. The horse herd was five distant dots.

What a great way for horses to live, I thought, and was glad that I'd been able to give Danny and Twister the chance to be relatively free, living as horses were meant to live. Suddenly I was eager to turn Gunner out, to see him running with the herd, leading a horse's natural life. It seemed an appropriate reward to give my old buddy, who had done so much for me.

Finishing up with the salad, I carried it outside.

"Evening's still nice," Blue said. "Shall we eat outside?"

"Sure," I agreed, and begin gathering plates and utensils and bringing them to the picnic table.

Freckles lay curled up by the fire, tail over her nose, paws still muddy, looking tired and content. I thought briefly and sadly of Roey, who had loved camping trips. In her youth she'd been my companion on a solitary horse packing trip across the Sierra Nevada Mountains. The pack trip on which I'd met my husband. I smiled at Blue.

Blue met my eyes and smiled back.

"Freckles looks happy," I said, gesturing at the dog.

Mac, too, looked at Freckles. "I miss Roey," he said.

I glanced at my son, still surprised, after all these years, at

the way he could read my mind. Along with his ethereal appearance Mac seemed to possess uncanny psychic abilities. Over and over again he would correctly intuit my thoughts, or accurately interpret a situation of which he had no firsthand knowledge. His instincts about the world were invariably dead on.

"We all miss Roey," I agreed, watching his wistful face.

"I miss Toby, too. And Baxter." Mac's eyes were fixed on the fire.

In some strange, sad twist of fate, Toby, Mac's pony, and Baxter, his favorite cat, had died within a week of each other last fall. And then, this spring, we'd had to put Roey down. It was a lot for a little boy to deal with.

"I miss Toby and Baxter, too," I told Mac. "It's hard when our animals die."

"Are their spirits still with us?" Mac stared upward at the slowly darkening sky between the oak trees.

"I think they are," I said. "I think Toby and Baxter and Roey are still taking care of you. See those two big rocks over by the corrals?" I pointed out two monoliths, side by side.

"Yes. I see them." Mac looked at me.

"That's where Burt and Pistol are buried. They were two horses Lonny had back when he lived on the coast, near us. Burt was the horse that taught me how to rope. And Pistol was a great horse, too. Lonny buried them here when they died. He says they look after the place."

"We buried Toby and Roey and Baxter at home," Mac said. "Will they look after us here?"

"Of course they will," I said. "Their spirits will stay with us. And Burt and Pistol will watch over us, too."

Mac smiled. Somehow this notion was reassuring. I watched my little boy and wondered why life had chosen to deal us this particular hand. Sure, he was learning about mortality early, it would always be a given to him, and perhaps this was a good thing, but it seemed an awfully heavy burden for those slender

shoulders to bear. I didn't really know what to say that would be helpful. Death was unbearably final, undeniably sad, and all around us. I did the best I could to provide some comfort.

Wordlessly Mac moved around the fire until he leaned on my knee. I lifted him up in my lap, something he seldom requested anymore, and kissed his temple. For a moment he rested against me, and then wiggled to get down. I let him go.

At times motherhood seemed to be an endless letting go. Mac's growth was a constant process of separating from me, a steady movement away from our complete unity in the days when we had both shared my body. Once born and in my arms, my helpless baby had become a self-willed toddler and now an independent little boy. Soon, as I well knew, he would be the rebellious teenager, and eventually, the adult who would be my equal, and if we both lived long enough, my caregiver.

I sighed. A lot to take in, sitting by a smoky campfire, wishing I could hold my little boy just a tiny bit longer. But Mac was watching his father remove the steaks from the fire and set them on a plate. It was time to eat.

We'd just finished dinner when we saw the headlights bouncing down the ranch road toward us. Freckles woofed. Blue studied the car a minute and then glanced over at me.

"Looks like your friend Bret is coming back," he said.

Chapter 4

DUSK WAS nearly dark as the sedan pulled up in front of our camp. Headlights clicked off. The almost-round shape of a gibbous moon shone through the oak trees on the eastern ridge. In the faint silver-white light, I saw Bret's hair gleam, pale and gray, as he got out of the car. Odd to think of Bret with gray hair.

Blue stood up as Bret opened the gate and walked up to the campfire. Mac stepped behind me. Freckles wagged her tail and sniffed Bret's hand. And Bret grinned, his old grin, and regarded the group of us a little ruefully. None of us seemed to know what to say.

I finally opened my mouth. "What happened?"

I'm not sure what I meant, but Bret answered with, "Lonny's in jail. They'll charge him in a couple of days. I think they'll set bail. He'll be out."

"Okay," I said, "but what happened to get him into this situation?"

"That's a long story." Bret glanced at an empty chair.

"Care for a drink?" Blue asked, ever the polite host.

"Can't. I'm still on."

"Do you have time to sit down and fill us in?" Blue's voice was calm and courteous, as if this were a normal social situation.

"I'll try." Bret sat down in the empty chair and propped his feet up on one of the small boulders that formed the firepit.

Mac settled himself in the chair next to me, his eyes on Bret. Freckles curled back up in the slight cavity she'd excavated, tail wrapped over her nose. Blue swirled the amber liquid in his glass and sipped; he'd moved on to whisky.

As for me, I stared at Bret's face in the firelight and waited. My old friend's features looked both familiar and strange. I couldn't get over the silver hair; the thickened jawline and fine wrinkles around the eyes were different, too. But the quick flash of humor in the eyes and the three-cornered grin showing crooked teeth were just as they had always been. Bret was still Bret.

"What happened?" I asked again. "Who are these people who," I glanced at Mac, "umm, are no more?"

Bret shook his head. "The short answer is, they're Lorene and Cole Richardson, sister and brother. They're part of a local family; they run the livestock auction here in town."

"And Lorene was Lonny's girlfriend?"

"Lonny and Lorene were known to be seeing each other," Bret said carefully. "Nobody really knows how involved they were except Lonny. They didn't live together," Bret added after a moment. "Lorene just got divorced from Kevin Moore last year."

This didn't mean anything to me, which Bret could see. "Kevin Moore's another local rancher," he said. "He didn't care for Lonny dating his ex."

"Oh," I said. "So what happened, exactly, to Lorene and Cole?"

Bret glanced over at Mac and then back at me. "My kids are almost teenagers now," he said.

I got the point immediately. "You've got two, right?" I said. "A boy and a girl. I'm sorry; I can't bring their names to mind."

"Audrey and Sam," Bret said. "They're eleven and twelve."

Bret smiled at Mac, who smiled shyly back and immediately dropped his eyes. It took Mac a while to warm up to strangers.

"How old are you?" Bret asked Mac.

"Six years old," Mac said softly.

"So, how come you're not in school?"

Bret looked at me as he said this, and I answered for Mac. "We're homeschoolers. Makes it easy to take trips. And I really believe it's the best way to educate a child. You have the freedom to make choices that fit that individual. You spend time together as a family. And I'm not impressed with what kids learn in schools."

Seeing Bret's slightly surprised expression, I closed my mouth on the next bit of tirade. "I'm sorry. End of rant. It's just something I feel strongly about. I know other people feel differently."

"Come on, kiddo, time for bed," Blue said to Mac.

As he herded a protesting Mac into the camper, Blue gave a quick jerk of his chin in my direction. I got the message. Bret and I could talk more freely.

"What happened?" I said yet again, in a soft voice.

Bret knew what I meant. "Lorene and Cole were both shot last night at the saleyard. After hours. The usual Saturday sale was over. They were found in the office. The gun that killed them was on the floor; it was Lonny's gun. His fingerprints were on it— nobody else's. Someone saw Lonny driving out of the saleyard. Looks pretty bad for Lonny."

"Lonny didn't do it," I protested. "I know he didn't do it."

"I'm not arguing," Bret said. "I'm just telling you so you can understand why we arrested him. John Green, the detective, is sure he's got his man."

I was trying to comprehend all this. "Who saw him leaving the saleyard?"

"Guy whose place is next door. Small-time rancher named Justin Roberts. Said he saw Lonny's pickup pulling out the front gate, about an hour before Blake, that's the other Richardson brother, found Cole and Lorene."

"And Lonny's gun was found?"

"That's right. On the floor, next to the bodies. It was definitely the gun that killed them. And only Lonny's fingerprints were on it."

"Damn," I said. "I see what you mean about it looking bad. But I still know Lonny didn't do it."

"Yep," Bret agreed. "I can't see old Lonny doing something like that. Not under any circumstances."

"What's his motive supposed to be?"

"Yeah," said Bret. "That's kind of the sticky part. Everyone knows he was going out with Lorene. Her ex wasn't happy about it; that was common knowledge. People say that Lorene was seeing Kevin, that's her ex, again. Apparently Lonny had a little barbecue over here at his place on Friday and he got in an argument with Lorene over Kevin. Not to mention he threw Kevin out of his house. So old John Green thinks he's got a 'crime of passion.'"

"Lonny?" I said incredulously. "No way. And why is he supposed to have killed her brother?"

"Because Cole walked in on him when he shot Lorene. That's what John thinks."

I shook my head. "I can't see it. But that's because I know Lonny."

"Nobody who knows Lonny can believe it."

I could hear rustles and thuds from inside the camper. Blue was putting Mac to bed. Sudden shrieks and giggles indicated that some wrestling might be going on.

I shook my head again. "I need to go be the mean mama," I said. "Left to themselves those guys will just wrestle all night."

"I've got to go, anyway," Bret said. "My shift's just halfway done. I'll try to come by tomorrow, when I'm off."

"Good," I said. "It's good to see you." I tried to smile. "Though I wish it were in happier circumstances."

"Me, too," Bret agreed. "Say good-bye to your husband and son for me."

"I will." And I watched him walk out to the car, climb in, and drive away.

Inside the camper, all was pandemonium. Mac and Blue were wrestling on the bed; judging by the discarded book lying on the quilt, Blue had begun by reading the time-honored bedtime story to his son, and things had progressed in their usual fashion.

As I watched Mac and Blue giggle and roll around like a pair of puppies, I could feel the slow smile spreading across my face. After an evening full of shocks and disaster, the sight of my two guys roughhousing together was reassuringly normal.

Freckles wagged her tail ingratiatingly at me; she wanted to be fed. I gathered some steak scraps and dog food crumbles and made her a meal, listening to the shrieks, giggles, and thumps from the bed meanwhile.

Finally, as Freckles finished gobbling her dinner, I intervened, half-reluctantly. "Bedtime," I said, "at least for me."

Blue glanced my way from his position in a headlock and grinned. "Mama wants to go to sleep," he said.

Mac muttered rebelliously, but subsided with minimal protests; I could tell by his flushed cheeks and heavy-lidded eyes that he was tired. Why wouldn't he be? We'd had a long day; I was tired, too.

Stripping down to a tank top and underwear, I climbed up on the bed. Freckles jumped up behind me. Blue and Mac had already wiggled under the covers. With a certain amount of shuffling and realignment, the four of us settled down to sleep, cuddled up together, a quiet, happy little pack.

Moonlight poured in through the camper windows, illuminating Mac's features on the pillow next to mine. I could feel Blue's long arm wrapped around us both and I smiled.

Some hours later I awoke to the howls and yips of coyotes. Lying still, I listened to the singing, trying to determine how close they

were. Freckles growled low in her throat. The next ridge over, I thought, not here. But I peered out the window anyway, hoping to spot a silhouetted shape.

The moon was high and lit up the landscape in silver and black; I could see oak trees and boulders clearly in a ghostly parody of high noon. Our three horses stood in the corrals, ears pricked forward alertly in the direction of the coyote music.

I looked in that direction, too, but saw no sharp-eared, dog-like forms. Nothing but grass and trees, rocks and sky. Except... I stared. Surely that was a horse. Off in the distance, moving along the ridgeline.

I stared. What the hell? Not one of the horse herd. Moving briskly along the ridge was the purposeful shape of a trotting horse—with a rider on him.

Chapter 5

I BLINKED, not quite believing what I was seeing. And then Plumber nickered.

One by one the other horses followed suit, calling out a greeting. Their eyes, like mine, were fixed on the receding shape of the distant horse in the moonlight. Plumber nickered again.

Pressing my face to the window, I strained to see, but the mounted horseman topped the ridge and disappeared, moving in the general direction of Lonny's house. Coyotes howled; crickets chirped. Otherwise the night was undisturbed.

I shook my head. The rider, now vanished, seemed like a dream, and yet I was certain that I'd seen him. A dark human silhouette on a dark horse, moving at the long trot, sharp in the moonlight. Here, on Lonny's property. Who could it possibly have been?

Shivering a little, I peered out the window in the direction the rider had disappeared. Thank God our horses had nickered to the stranger; otherwise I'd be sure my imagination had gone berserk.

I thought of waking Blue, but hesitated. What would we do, start chasing this unknown horseman down? What would be the point exactly? And what did we know about this place? Perhaps

one of Lonny's neighbors routinely took moonlit rides on his place. Maybe the neighbor he'd called Kate, who knew something about Sunny. How would I know?

Still, it seemed odd. Especially under the current circumstances. Lonny had just been arrested for murder and now an unknown horseman was crossing Lonny's property at, what, I glanced at Blue's watch, shortly after midnight. Odd, for sure.

Blue and Mac snored peacefully on. Freckles, curled in a brown-and-white spotted ball at my feet, regarded me curiously. The coyotes were silent now.

I pondered what I'd seen, or thought I'd seen, for what seemed like hours, but was probably only minutes. Thoughts chased through my mind, each notion more fantastic than the next. Slowly my mystery rider evolved into the headless horseman and then a flying lizard. My eyes closed.

When I opened them the faint gray light above the eastern horizon told me dawn was coming. Mac, Blue, and Freckles slept on. In the corrals our three horses stood quietly in a horse's classic resting pose, one hind leg cocked.

For a minute I lay there in a sleepy fog, relaxed and content, admiring the perfect stillness of Mac's sleeping face, the half moons of his lashes on the soft cheeks, the relaxed bow of his mouth, gently parted. All was well with my world.

And then I remembered the rider. For a second I was confused, unsure whether I was recalling a dream. Then I remembered the horses nickering. Not a dream. A real horse. With a rider.

Climbing out of bed, I put the kettle on for coffee and tea. The interior of the camper formed itself around me, a portable home, like a turtle's shell. It made me smile. The walls with their neatly fitted wooden cabinets, the small table in the windowed corner, the tiny closet of a bathroom, the little stove and sink. There was something very nice about this little box of a house in the back of a pickup truck. I felt as if I'd become a gypsy, travel-

ing in my wagon. Home was wherever I made camp. The notion pleased me.

I grabbed my favorite shawl out of my travel bag. Woven of rough, natural silk, it was straw gold, the texture of linen, and incredibly light and warm. Draping it around my shoulders, I admired, as I always did, the subtle interplay of light and shadow on the hand-woven cross-hatched fabric. Now I looked suitably gypsy-like.

The sky above the eastern ridge turned from gray to salmon. The kettle whistled. I made myself a cup of tea and sat down at the table to drink it. My three companions in the bed didn't stir.

Dawn's light didn't make the puzzle of the mystery horseman any plainer. Nor did it help illuminate the more pressing puzzle of Lonny's predicament. I sipped tea and chewed on my thoughts, which weren't very productive. Without knowing any of the players in this little drama, I had no way of even guessing at a possible scenario that might hold an answer. Who killed the auctioneer and his sister? That was the question.

The quilt on the bed shifted and Blue's head appeared, his long red-gold curls wildly tangled.

"Want coffee?" I asked.

"Sure." Blue looked groggy.

After a minute he emerged from the bed and climbed down to join me at the table. I poured him a cup of coffee and waited until he appeared a little less stunned, about half a cup, before I told him about the mystery horse. Then I had to recount all the information Bret had given me last night.

Blue's expression grew quite a bit more focused as he contemplated this.

"Who in the world would be riding across this property at midnight?" I asked him. "Don't you think that's weird?"

"Yeah, that is weird," Blue said.

"I have no idea what to make of it."

Blue had an easier time compartmentalizing things than I

did. Lifting one shoulder slightly, he dismissed the horseman as a problem he couldn't solve.

"Shall we go for a ride this morning?" he asked me.

"Sure. I thought Lonny would be able to point us in the right direction, but I guess we'll have to experiment."

"Yep." Blue took a sip of coffee.

"I'll go feed the horses," I offered.

"Okay. If Mac wakes up I'll feed him breakfast," Blue said.

Draping my shawl over the end of the bed, I put on cotton cargo pants and zipped a hooded sweatshirt over my tank top, then pulled fleece-lined leather boots on my feet. Ready. I ignored the fact that my hair wasn't brushed. We were camping, after all.

And then it was out the camper door into the crisp, sweet air of the early morning. The first rays of the sun slanted over the eastern ridge and through the branches of the oak trees, and wide swathes of yellow-gold light lit up the meadow. Plumber spotted me and nickered; Gunner and Henry chimed in.

"Feed us," they said.

"I'm coming." I smiled. A horse's morning greeting is a cheerful thing.

I distributed hay to the three geldings in the pens and looked around. The pasture-horse herd was nowhere to be seen. A meadowlark trilled with excitement out in the wide green field. I could see the azure flash of a bluebird's wing in the closest oak tree. Mesmerized, I watched the little spark of lapis blue and rust red flicker from branch to branch until it flew away over the creek, running dark in the shadows between its banks. I strolled in that direction, watching the steam from my teacup rise into the chilly early morning air. Freckles trotted at my heels.

For a moment I forgot about Lonny and his problems and rejoiced in the beauty of the scene and my freedom. Blue and Mac and I were here at last. On vacation in the Sierra foothills with our horses and dog.

I began to walk along the creek, following a trail that the pasture horses had clearly created. The stream wound between trees and rock outcroppings; in a few minutes I was out of sight of camp. Another few minutes brought me to a spot where the water dove into a deep, rocky gully. At the bottom, it splashed from one granite bowl to another in a series of stair steps. The biggest of these bowls formed a pool about twenty feet in diameter. It looked deep in the middle. I smiled. There was our swimming hole.

But first breakfast and a ride. By then the day would warm up. I made my way back to the camper to find that Blue had sliced up an apple and made some toast for Mac. Toasting a few more pieces of bread, and making another cup of tea, I ate my own breakfast outside, sitting at the wooden table.

Blue and Mac took their time. I didn't rush them. That was part of the point. For just a short while we were going to do things when we felt like it, adhere to no schedule, have no need to hurry. We were going to relax. We were on vacation. My mantra.

Maybe an hour later my husband and son emerged from the camper. The sun was high enough in the sky to be warm. Our saddle horses were done eating.

"Want to go for a ride?" I asked my family.

"Yeah," said Mac enthusiastically.

"Sure." Blue indicated the pasture horses, who had ambled in for a drink. "You going to ride the palomino?"

"I hadn't thought about it. I guess I could."

I stared at chunky little Sunny, who stared back, his ears forward, as if he could read my mind. Gunner was definitely a little off in his left hind. But I had no idea what this yellow horse was like to ride.

I made a snap decision. "You catch him, I'll ride him. Let's put a couple of the others in the corrals to keep Gunner company."

Blue grinned. "I'll catch him, Stormy. Let's see what he's like."

I smiled at the familiar nickname. Blue had lived for many years in Australia, where redheads were routinely called Blue or Bluey, and women named Gail got the moniker of Stormy. Some of my husband's past lingered with us in our colorful names; it always tickled me.

Blue ended up catching and tying up all the pasture horses; we found it made things simpler. I saddled Henry for Mac and Plumber for Blue. Blue put my saddle on Sunny.

"I'd ride him for you," Blue's lips twitched, "but my feet would drag the ground."

"No problem. I'll ride him."

Sunny hadn't turned a hair throughout the catching and saddling process. Something in his steady gaze as he watched me gave me confidence.

Legging Mac up on Henry, I made sure his feet were snug in his tapadero stirrups and his helmet was settled squarely down over his forehead. Blue handed Sunny to me and swung up on Plumber.

I stared at my new mount, who stared back with a steady brown-eyed gaze. I had the sense that he was sizing me up in very much the same way in which I was checking him out. What have we here? He looked phlegmatic and sensible, if a little wary, not the sort of horse to do anything foolish.

I tightened the cinch and walked Sunny a step forward. Using my reins to tip his nose toward me, I stretched to put my left foot in the stirrup. No problem.

"I love little horses," I said to Blue, and swung on.

Sunny did absolutely nothing. He stood perfectly still while I found my right stirrup and gathered my reins, then plodded off when I clucked to him as if he'd done it every day of his life. His neck and shoulders looked thick, substantial, and sturdy in front of me; his ears were pricked sharply forward. He felt steady and strong, even if he did put his feet down with an audible thud.

"He looks like a babysitter." Blue grinned at me.

"He feels like one. Want to ride down and see the swimming hole?" I asked Mac.

"Sure, Mama."

"I'll show you where it is," I said.

Turning, I headed my little palomino plug down the trail, with my husband, son, and dog behind me.

Chapter 6

THE SWIMMING hole was a big hit with Mac and Blue, who couldn't wait to get in it. From there we rode across the meadow, toward the closest ridge. I had a notion to see if I could retrace the route the mystery horseman had taken.

In another few minutes I was guiding Sunny up the gentle slope. I looked to my right and saw our camper, parked in its grove of oak trees. I was now, more or less, in the spot where I had first seen the nighttime rider. I looked down. Plenty of hoof-prints there. Impossible to tell which were those of the pasture-horse herd and which were not. I kept riding, taking the line that the rider had taken.

We dropped down into a small saddle between two hills, topped a rise, and descended into another valley. I followed the valley on a slightly uphill course as it curved gently around a bend. And there ahead of us, appearing from behind a screen of trees, was a house, flanked by a barn, corrals, and arena. I reined Sunny to a stop.

"That's Lonny's house," Mac said. He'd been there on the day we dropped Twister and Danny off.

I stared at the house, several thoughts chasing through my brain. It felt odd to be looking at Lonny's home while Lonny him-

self was in jail. Almost as if we were trespassing. And if that night rider had followed the same course we did, he would have ended up here, too. And then what? I had no idea. But the big, silent, half-timbered house did not seem welcoming.

"There's no point in going down there if Lonny's not there," I said to Blue. "It doesn't feel right."

"I agree."

"Didn't Lonny say that the gal who found this horse for him lived just on the other side of that road?" I gestured at a dirt road that snaked up the hill on the far side of Lonny's pasture fence. "I'd like to find out a little more about this guy."

"Lead on," Blue said.

I lined Sunny out along a well-used trail that led toward the fence. He plodded agreeably in the direction I pointed him, not too fast, but not balky either. He carried his head low, ears tipped sharply forward, watching everything. So far he showed no inclination to spook, jig, or resist me in any way. He hadn't tripped once, though he put his feet down more like a draft horse than the well-bred cowhorses I was used to. Still, I felt secure and comfortable on his back. I was beginning to think I might take Lonny up on his offer.

"So, do you like your little yellow mule?" I could see Blue's smile as I looked over my shoulder at the sound of his voice.

"Why do you call him a mule? He's cute," I protested.

"In a common sort of way. I don't know. Something about his expression."

"I know what you mean," I agreed. "His ears are a little long, too. And yeah, I like him."

"I love the horse I ride," Mac announced, his smile as wide as the sky.

"Henry's a good one," Blue agreed.

I grinned over my shoulder at my little boy on top of his steady copper red horse. Henry's white-striped face bobbed rhythmically in time to his walking stride, his demeanor quiet and calm, as always. Mac's eyes were dancing with delight as our cavalcade trooped up the hill toward the fenceline. Green grass swooped away in rolling curves on all sides; a redtail hawk circled overhead. Freckles trotted behind Plumber at the rear of the parade. In the moment, my heart soared like the hawk.

"Look," Mac pointed.

I followed his finger and saw a small white house half-concealed by oak trees. It sat outside the pasture fence, on the other side of the dirt road. This must be Kate's house. Kate, who had somehow managed to pick out my next horse for me.

I stared down at the curve of bright gold neck in front of me, topped with a sweep of cream-white mane. I'd never had a palomino before. I was surprised by how attracted I felt to this horse's sunshine gold exterior. The buttermilk-colored ears were pricked sharply forward, looking around, as they had been throughout the ride. I liked a horse who kept his ears forward. I wondered how Kate had acquired this horse, and how Lonny had ended up with him and decided to give him to me. Maybe I would find out.

I could see what looked like a child, swinging in a tire suspended by a rope from a branch of an oak tree by the house. Somebody was home.

Sunny trudged steadily up the hill, his focus on what now appeared to be a little girl with long, light brown hair, twirling in a tire swing. Mac was watching her, too, his face slightly averted. In another minute we had reached the fence. The trail ended at a wire gate, stretched tight. Lined up in a row in front of the gate, we all peered across the road at the girl. I could see some corrals under the trees behind the house, a few horses in the corrals.

The girl's eyes traveled over our little group and stopped on me. "Hi," I said.

In another instant she was off the swing and running to the house. "Mom," she called. "That lady's riding Sunny."

In response to this a woman stepped out the door and onto the porch, then down the steps and across her yard, headed in our direction. A short, trim woman with dark red hair in a ponytail, a snug black tank top and snugger jeans. I glanced sideways at Blue, who was watching the new arrival appreciatively. It figured.

"Hi," I said, as the gal came to a stop near the fence. "I'm Gail McCarthy, and this is my husband, Blue, and my son, Mac. We're here visiting Lonny. Lonny offered to give me this horse I'm on. He said you would know about him. That is, if you're Kate."

The woman standing in front of me looked tense, almost belligerent. I wondered if I'd said something to offend her, though I couldn't think what it would be. Jaw clenched, she glanced over her shoulder to see that her daughter was back on the tire swing. Then she looked back at me.

"Yeah, I'm Kate," she said.

I got the impression she was watching me for a reaction, but my face must have looked as blank as I felt. She gave a tiny— almost imperceptible—shrug and went on.

"I got that horse at the livestock auction for twenty-five dollars. He was skin and bones. I heard some horse trader bought him in old Mexico and then ran out of money to feed him and just dumped him at the saleyard. The kill buyers wouldn't buy

him—too thin. After I got a little weight on him, I gave him to Lonny to turn out. I told him he could find the horse a good home, if he wanted. He said he knew of one, maybe. Are you it?"

All this was said quickly, as if the woman just wanted to get this conversation over with. Her eyes moved uneasily from side to side as she spoke. She seemed to be watching for something.

"I might be," I said. "Do you know how old he is?" I asked. "Or if he has any soundness issues?"

The woman shrugged. "I never vetted him. I just fed him. I've never seen him limp. Vet him if you want to."

"I'm a vet," I said.

Kate's eyes showed a flicker of curiosity, which quickly dimmed. When she spoke, her voice was curt. "Do you know what's going on with Lonny? I heard some rumor they suspect him of those murders at the saleyard?"

"He's been arrested. Bret, the deputy," I could hardly get my mouth around those words, "thinks he'll be out on bail in a couple of days."

Kate shook her head. Her eyes seemed to be watching some distant movie that only she could see. "Lonny, arrested? Jesus. Lonny didn't murder Lorene. Shit."

At least Kate seemed to agree with my own view of the situation. The subject of Lonny reminded me of the mystery horseman. Maybe Kate would know the answer to this puzzle.

"Do you have any idea who might have been riding a horse across this pasture last night?" I was unprepared for her reaction.

"What?" Kate's distracted eyes shot to my face, her jaw literally dropped. "What are you talking about?"

I couldn't tell if she was angry or alarmed. "Coyotes howling last night woke me up and I saw someone riding along that ridge." I gestured over my shoulder. "Around midnight. Any idea who it might have been?"

"You think you saw someone riding here? Are you sure? May-

be you saw one of Lonny's horses." Kate's voice was intense, her face guarded. I couldn't figure out what the underlying emotion was.

I tried again. "I'm sure it was a rider on a horse. Any ideas who it might have been?"

Kate just stared at me.

I was lost. I looked over at Blue and could tell he was as puzzled as I was. Mac was watching the little girl spin on her tire swing. I took another shot at it.

"Do you have any idea who might have been riding here last night?"

This time Kate seemed to hear me. Her eyes rested on mine. She appeared to be thinking.

"No," she said at last.

I was willing to bet that this was an outright lie. Kate definitely had some kind of theory about the mystery rider. She just wasn't planning on sharing it with me.

Nothing I could do about this. I wasn't empowered to grill her. Maybe I could talk Bret into it. For the present, I said, "Well, nice to meet you," and turned to go.

"Take good care of Sunny," she called after me. "He's a good horse. I've ridden him some. He's gentle. I've even let my daughter ride him."

"Sure," I said. "I don't know if I'm going to keep him, but if I do, I'll take good care of him."

But even as I rode off down the hill, I knew that I was lying, too. As I watched the white-gold sun sparks on the shiny side of my mount's bright neck, I was sure. Sunny was going to be my horse.

Chapter 7

WE WERE back in camp an hour later. I'd unsaddled Sunny and was regarding my new acquisition with some curiosity. Looping the leadrope over my arm, I slipped my thumb into Sunny's mouth and tried to hold his jaw open with my hands so I could look at his teeth. Tried was the operative word. Sunny wanted no part of being mouthed. He threw his head high in the air and flew three quick steps backward.

I stopped him with the leadrope and we stared at each other. "Come on, Sunny," I said, and made another attempt. No dice. Sunny jerked back even more emphatically and braced all four legs.

I stared at him quizzically. Sunny's expression was confident and challenging, not scared. Sunny didn't want me peering in his mouth and aimed to prevent it. Looked like my little yellow plug was a horse with an opinion.

Blue laughed. "Well, they do say not to look a gift horse in the mouth."

I shook my head. "And there he is, the proverb in the flesh."

I knew that Blue, a competent horseman, would have realized exactly why I wanted to look in Sunny's mouth. As a vet, I

had enough training to make a reasonable guess as to Sunny's age if I could get a good look at his teeth. Which apparently wasn't going to happen without a battle. Or a tranquilizer.

I didn't feel like a battle. Nor did I feel like digging a tranquilizer out of my vet kit. I was on vacation.

"Want me to twitch him?" Blue asked.

"Sure," I said. "Let's see how he responds to that."

Blue took hold of the leadrope, grabbed a pinch of Sunny's skin along his neck, and twisted it. Just hard enough to hurt a little and distract the horse from what I was doing. Sunny froze. I was able to open his mouth and have a look. After a couple of seconds I let go of his jaw and Blue released his grip. Sunny stared at both of us, quite unperturbed. It obviously took a lot to ruffle this horse.

"So, how old is he?" Blue asked.

I shrugged. "Hard to tell. He has funny teeth. It's like the lower ones don't match the upper ones. Somewhere between ten and fifteen, I'd guess."

"Just right," Blue said.

"Yeah," I said, and slipped Sunny's halter off and turned him loose.

"Go on, you ornery little thing," I said.

Paradoxically, now that he was free, Sunny stood his ground, watching me, his ears pricked forward in my direction.

"He has the cutest expression," I told Blue. "Interested and wary, like he wants to be friends but isn't sure."

Blue smiled. "He looks at you right," was all he said. "Let's have lunch."

We had just finished our roast beef sandwiches when a small blue Jeep drove up to the campsite; I recognized the silver-haired driver as Bret. He climbed out of the Jeep, gave us a grin, patted Freckles, shook Blue's hand, high-fived Mac, and tossed me a quizzical look. "How you doing?" he asked.

"Okay," I answered. "I think I've got a new horse."

"You're gonna take that little palomino?"

"Yep," I said, "I think I am."

"Did you talk to Kate about him?"

"I tried," I said. "I didn't learn much. What's the deal with Kate?"

Bret grinned again. "She's a celebrity," he said. "An internet celebrity. She's 'Rescue Horses.'" He spelled it: "resqhorses." And he looked at me expectantly.

"What's that?" I asked.

"It's a blog," Bret said. "Kate is a famous blogger. She's an anti-slaughter advocate for horses."

I must have looked as puzzled as I felt, because Bret shook his head. "Don't you know what a blog is?"

"Not really," I said. "I know it's the trendy internet thing, that's all. Sort of like publishing your personal diary for the world to read, right?"

Bret laughed. "Not exactly. In Kate's case, hers is all about exposing what evil things people do to horses. Trainers who are cruel, owners who sell their old retired pets to slaughter, backyard breeders who breed horses that are such crap that they're bound to end up slaughtered, stuff like that. It's actually fun to read," he added. "She's a hoot."

"Okay," I said. I was less than interested in the nebulous subject of blogs. "She didn't tell me much about Sunny, other than he came from the livestock auction and was real thin when she bought him."

"That's right," Bret agreed. "I was there the day she bought him. Pathetic little skeleton of a horse. He looks a whole lot different now."

"Why did she buy him?" I asked.

"That's what she does. She rescues horses that would just end up at the killers. When she finds a home for one, she rescues

another one. She had Lonny talked into taking Sunny. I guess he was thinking you might want him. But yeah, that's what she does. She writes this blog about stopping the slaughter of horses and rescues as many horses as she can. It's her whole life."

"What pays for all this?" I was mildly curious now.

"I think she gets donations." Bret shrugged. "She doesn't live high on the hog, that's for sure. She and her daughter have that little shack of a house with a few corrals out back; you must have seen it if you talked to her."

"Yeah," I said. "So, how's Lonny doing?"

"Okay, I guess." Bret looked down. "He's not very happy, naturally." He glanced back up at me, his wary green-brown eyes the same as they were twenty years ago. Lots more lines around them, though. "I wondered if you'd want to go for a ride. See the saleyard. You, too," he added to Blue.

Blue looked amused. "No thanks," he said. "Mac and I are going swimming. Right, Mac?"

"That's right, Papa." Mac smiled a wide and happy smile.

"Go, if you want to," Blue said to me.

I thought. Spending time at the swimming hole with Blue and Mac was very appealing, but presumably I had a few more days to do this. And I was genuinely curious about this sordid crime that had landed Lonny in jail. This might be my one chance to find out more from Bret.

"Sure," I said. "I'll go. Are you investigating?"

"Me?" He looked shocked. "Heck, no. I'm off duty. I'm not a detective, anyway. John would have my butt if I started investigating behind his back. I just thought I could show you the scene. Explain a little more." He cast a significant glance at Mac.

"Okay," I said. "I'm ready whenever you are. I'm going for a ride with Bret," I added to Mac. "I'll meet you and Papa at the swimming hole later."

Fortunately Mac was too focused on swimming to be very

interested in what I was up to. He assented with a murmur, his attention fixed on his father.

"See you later," Blue said as I climbed into the passenger side of the Jeep.

"See you," I called as Bret put the thing in gear and we bounced forward.

To my surprise, Bret headed off across the pasture, rather than re-tracing his route along the ranch road.

"Where are we going?" I asked as the Jeep jerked into a shallow gully and out the other side.

"There's a gate on the far side of Lonny's field that leads to a dirt road. That road will take us to the saleyard. It's the back way."

I was thinking fast. A gate at the far end of the field. My mystery rider, headed along the ridge toward Lonny's house. Bingo.

"Is this gate locked?" I asked Bret.

"Nope," he answered. "Lonny never locks anything up. His house is wide open, too."

I could see the gate ahead of us—a silver aluminum panel breaking the almost invisible lines of the smooth wire fence. If the horseman had come through that gate and headed across the pasture toward Lonny's house, he or she could easily have traversed the ridge and passed by our camp right about the spot where I'd seen the moonlit silhouette.

"Listen," I said to Bret, and recounted my story.

"That's weird," he agreed, when I was done, and looked as mystified as I felt. "What would be the point of coming here on horseback at midnight?"

"I was hoping you could tell me," I said, as I hopped out of the Jeep to open the gate.

Bret drove through and I shut the gate behind him. In another moment we were bouncing down a dirt road between rounded green hills at a greater rate of knots than I would have chosen, Bret wearing a purposeful expression behind the steering wheel.

"Whose property is this?" I asked, gesturing at the ranch land we were passing.

"Right-hand side of the road is Donna Wells' place. Left-hand side is Kevin Moore."

The second name sounded familiar, but I couldn't place it. "I don't see any houses or barns," I said.

"These are big places, both of them. Several thousand acres each. You can't see their houses from here. Donna and Kevin both raise cattle; they've got lots of ground. Lonny's little gentleman's horse ranch is the only one in this valley."

"Kate must really be the low-rent district," I said.

"She is." Bret grinned. "Not real popular with the locals, old Kate."

"Why?" I asked, though I thought I already knew.

"The ranchers don't agree with her anti-slaughter campaign," Bret said. "She's always hassling the Richardsons, who run the livestock auction, and they're a real important local family. Nobody likes it."

"So why isn't Kate a suspect when two of the Richardson family get murdered?"

Bret spat what I thought was probably tobacco juice out the side of the Jeep. "Like I said, there's too much evidence against Lonny. John, the detective, is an old, fat, lazy cop. Just between you and me, and I hope you'll keep it to yourself. He's not going to look any further for a suspect." Bret was quiet for a second, his eyes on the bumps ahead. "I can't see Kate shooting those two. What motive would she have?"

"But someone shot them. And since we assume it wasn't Lonny, it has to be someone else. And Kate acted really strange when I was talking to her this morning. I couldn't tell if she was angry or upset or if she's always kind of hostile, but she sure acted like something was bugging her. And she's passionate about stopping the slaughter of horses. Sounds like a motive to kill an auctioneer

to me, at least as good a motive as Lonny's supposed to have. Got any ideas, if you don't like Kate?"

I could tell that Bret did have some ideas; even after a hiatus of ten years, my childhood friend's expressions were instantly familiar to me and I found myself recalling his typical behaviors without any effort. Bret was quiet, looking ahead, pointedly not answering me. I knew this meant that he didn't choose to share his thoughts with me. I also knew that no amount of coaxing was likely to change his stance. Bret had always been secretive.

Five minutes and lots of rolling oak tree-and-granite-studded hills later, Bret gestured at an old stone house off to the right at the end of a winding drive, next to the creek, with a barn, a set of corrals, and an arena beside it. "Donna Wells' place," he said.

The house was pretty and the yard well-tended. I could see some shiny horses in the corrals. The whole place looked simple and pleasant.

"Who's Donna Wells?" I asked.

"Biggest landowner in these parts," Bret said. "She inherited the place from her parents. She was raised in that stone house."

"Is she married?"

"She was. Twice. She's single now. Rumor has it she was seeing Cole Richardson."

"The one who was killed? The auctioneer?"

"That's right. Lorene's brother."

"Oh," I said, wondering if I would ever be able to keep this local infrastructure straight in my head.

Bret smiled, as if he intuited my thought. "Everybody around here is either related to, or has been at one time or another said to be seeing everybody else around here. It's confusing."

"What about Kate?" I asked. For some reason I was interested in Kate. "Anybody supposed to have been seeing her?"

"Nope. Like I told you, the locals don't like her. They avoid her."

"She's good looking," I said. "I bet some of these locals have noticed."

Bret shrugged, and pointed again, this time to a big house on top of a hill to the left of the road. "Kevin Moore's place."

"Who's he? I know I've heard that name."

"Lorene's ex. Who was apparently trying to get back together with her. He and Lonny weren't on the best of terms. A couple of people heard them arguing at that barbecue Lonny had on Friday. And then Lonny threw him out."

"Oh," I said again.

"Kevin Moore has a lot of money," Bret added. "People say Lorene left him because he ran around on her."

"What do you think?"

"I think he ran around on her all right." Bret grinned. "I don't know if that's why she left him."

Our dirt road was bending to the right, moving away from the route of the stream, which was dropping into a narrow canyon, the canyon that Blue, Mac, and I had come up yesterday, via the old highway. The road we were on ran between low hills, following level ground toward what looked like another big valley ahead.

We passed a fenceline and Bret gestured to the right. "Justin Roberts' place."

"Now who's Justin Roberts?"

"He's a small-time rancher. His place borders the saleyard. He's the one who saw Lonny leaving the auction on Saturday evening."

"Right after Cole and Lorene were murdered?"

"Yeah."

"Does Justin Roberts have any reason to lie about that? Or any motive to kill the Richardsons? Maybe he didn't like having a livestock auction as a neighbor."

Bret shook his head. "Justin was friends with Cole. And he loves the cattle business. He sold cattle at the sale all the time.

He's just a small-time kind of a guy, but he really loves being a cowboy. And unfortunately he's not lying about seeing Lonny. Lonny admits it."

"He admits it?"

"Yep. He says he was there, all right. Stuck his head in the door of the office, asked Lorene if she wanted to go to dinner. He says Lorene told him she had more work to get through; they had a big sale that day. Lonny says he never saw Cole. He just said good-bye to Lorene and left. Justin saw him drive out." Bret pointed. "See that mailbox on the top of the next hill?"

"Yeah."

"That's Justin's driveway. He's got a little place up there. Runs a few cattle. When we get to the top of the hill, you'll see the saleyard."

I was thinking. "So, Blake, the other Richardson brother, found the bodies an hour after Justin saw Lonny?"

"Yep."

"And he never saw anyone else around the saleyard?"

"He doesn't remember seeing anyone in particular. But he was busy. Feeding the cattle, doing the chores."

"Right. So he might not have noticed someone who was being sneaky." I was still thinking. "So, Lonny's gun, with Lonny's fingerprints on it, was found at the scene?"

"You got it."

I shook my head, and then was sorry as the Jeep hit a deep rut, giving my half-twisted neck a painful jerk. "Has anybody wondered about that? Lonny would have to be an idiot to shoot those people and leave his gun there. He's not that dumb."

"I agree," Bret said. "John's taking the tack that it's a crime of passion. Lonny was crazy jealous that Lorene was breaking up with him and getting back together with Kevin. He wasn't thinking straight."

I snorted. "Not likely," I said. "I know Lonny."

Bret grinned. "Even I know Lonny well enough to know that's not him. But old John is sticking to his guns. He thinks he's got his man." Bret pointed through the windshield. "There's the yard."

I followed his hand and saw the array of corrals ahead and to the right, arranged around the skirts of a small hill. Surmounting the hill, surrounded by a gravel parking lot, mostly empty of cars, but full of various tractors, trailers, and pieces of equipment, was a battered red barn, which looked as if it held offices at one end. The local livestock auction. The end with the offices had some yellow crime-scene tape around it, I noticed.

Bret waved his pointing hand. *"Voilà,"* he said.

Chapter 8

WE HAD no sooner parked the Jeep and gotten out when two people approached us from opposite directions. One was a tall, slim, dark-haired man who came striding out of the corrals. The other, a shorter, stockier guy with a soft chin and close-cropped light brown hair, stepped out of a white pickup parked right in front of the saleyard offices. Both men wore Wrangler jeans, cowboy boots, and baseball caps, the de facto uniform for livestock folks. Bret, I noticed, was dressed the same. I knew that my loose brown cotton cargo pants and fleece-lined flat-soled boots marked me definitively as an outsider in this world.

"That's Blake Richardson," Bret said quietly to me, looking toward the taller man, "and Justin Roberts." Bret's eyes now pointed at the thickset guy walking across the lot from the truck.

"Oh," I said, and decided to keep quiet.

Neither one of the men was the least bit interested in me. Their eyes passed over me without comment; I could see that in both their minds I was some sort of non-essential accouterment of Bret's. Not his wife, not young or good looking enough to be a girlfriend, not dressed appropriately for a livestock person. Immediate dismissal from the mind.

It made sense, after all. Perhaps under other circumstances

there might have been some curiosity about me as a stranger, but at the moment the locals had one subject occupying their thoughts.

Blake Richardson reached us first. On close examination he proved to be a fairly handsome man of roughly forty, with a big nose, vividly blue eyes, dark hair showing gray at the temples, and a reserved, somewhat strained expression. Considering that he'd lost his brother and sister the night before last to a murder, he seemed pretty darn composed and calm, if a bit somber.

"Hey, Bret." Blake's voice was low. The three of us watched Justin Roberts approach.

When Justin was within a few feet of our little group, Blake jerked his chin in a greeting to him, and Justin nodded civilly in return. "Bret," he said, half smiling in our general direction. Both men glanced at me briefly and then looked away.

"Gail McCarthy," Bret said. "She's an old friend of mine. She's visiting from the coast with her husband and son."

The men made polite noises. Now I was placed. I noticed that Bret made no mention of the fact that the person I was visiting was actually Lonny. Both men had their eyes on Bret.

"Any news?" Blake asked.

Bret shrugged. "Lonny Peterson's been arrested. You knew that."

Some silence greeted his remark. No one protested that Lonny was surely innocent. They just waited.

I was finding that I didn't like these two men. Why, I couldn't say. The older I got the more I found that I responded to people's energy, the feeling that I got from them, more than I had any logical reasons for like or dislike. In this case, the tall man gave me an edgy, uncomfortable feeling, and the thickset Justin felt antagonistic, as if he were trying to dominate the situation. I had no idea what, if any, subtle body cues had given me this impression. Certainly not enough words had been said for the dialogue to be relevant.

I took a half step backward.

"Will they set bail?" Justin Roberts asked evenly.

Bret shrugged, and regarded Justin quietly, saying nothing. After a moment his attention shifted to Blake. "How're you doing?" he asked. The tone carried no emotion, but I was familiar enough with good-old-boy speak, and with Bret, to know it represented a form of sympathy.

"I'm okay," Blake said. "Getting through it. I'd like to know who killed my brother and sister, though."

"You don't think it was Lonny Peterson?" Justin Roberts looked genuinely curious.

Whatever answer Blake might have made was abandoned as all four of our heads turned in the direction of a fancy dark green dually pickup, which entered the parking lot, drove across it at a brisk clip, and pulled up next to our little group. The man inside rolled down the driver's-side window, turned off the engine, and spoke without leaving his seat.

"Any conclusions?"

I studied the speaker. He looked tall, though it was hard to tell, seeing him seated. He had brown eyes and hair and the sort of double chin that said he was carrying extra pounds. Like the other men, he wore a ball cap. Something in his lazy tone sounded inappropriate to our discussion.

"Kevin." The greeting came from Bret. The other two men obviously knew the newcomer; Blake met his eyes briefly; Justin Roberts' chin jerked up an inch. I supposed the driver of the truck to be Kevin Moore. Neighboring rancher who, if I remembered right, used to be married to Lorene, and had been dating her again. Had been heard arguing with Lonny at a recent barbecue at Lonny's house. Suspect number one, I decided, and looked at Kevin Moore with renewed interest.

The lazy brown eyes met mine with what I thought was considerably more curiosity than the other men had shown.

Bret saw the look and said, "This is Gail McCarthy, an old

friend of mine. She's visiting from the coast with her husband and son. Gail, this is Kevin Moore. His ranch is just down the road."

Kevin Moore touched the brim of his ball cap. "Nice to meet you, ma'am."

Something in the quiet drawl sounded sarcastic; why, I wasn't sure. The words were perfectly appropriate; it was the look in the man's eyes that seemed mocking. I nodded in his direction and said nothing.

Kevin Moore turned his attention to Bret. "So you guys put old Lonny in the clink."

"That's right." Bret met Kevin's eyes and said nothing. I smiled to myself. Bret was a master at this game. Nothing had changed.

For what seemed like a long time the two men stared at each other quietly. No one broke the silence. Kevin was the first to drop his eyes.

I was deciding that I liked Kevin Moore even less than I did Blake or Justin. Maybe I was just getting anti-social in my old age. Maybe Lonny being accused of these murders had upset me even more than I realized, and I was now suspicious of everyone. But I was getting a bad feeling from these men.

After another few seconds Blake spoke to Bret. "Do you guys think Lonny did this?"

Bret just shook his head. "You know what we found," he said quietly.

"Lonny's gun," Blake agreed. "And we know Lonny was here. But I wouldn't have thought he'd do something like that."

"Damn right he'd do something like that." Kevin Moore spat out his window. "Who else has a motive?"

The other two men said nothing. All three of them watched Bret. Clearly the locals wanted to know what tack the sheriff's department would be taking.

Bret stared into the middle distance for a while, and then spat on the ground and shrugged. "More than my job's worth to

talk about it," he said evenly. "I'd better go. I was just giving Gail, here, a tour of the local sights."

Kevin Moore half smiled. "Had to include the site of our latest local drama, huh?" He did not sound particularly heartbroken for a man who had just lost his ex-wife and current squeeze.

"That's right," Bret said, and took a step toward the Jeep.

As if realizing how cavalier he appeared, Kevin Moore met Bret's eyes with a sudden show of seriousness. "I'm not gonna forget about Lorene," he said. "If Lonny killed her, I want you guys to make sure he pays for it."

Bret nodded as if Kevin had mouthed a meaningless pleasantry. Taking his cue, I followed suit with a "Nice to meet you all," and moved after him toward the Jeep.

Various polite murmurs followed us from the men. Blake Richardson and Justin Roberts remained standing by Kevin Moore's open window as we drove out of the parking lot. I could see Justin's mouth opened in speech.

"I wish we could hear what they're saying," I said to Bret.

"They'll be a lot more free when I'm gone," he answered. "They'll be speculating on whether Lonny did it."

"Can they possibly believe he did?"

"I dunno." Bret shrugged his right shoulder. "Maybe one of them has got a reason to want us to think that."

"Kevin Moore, you mean? Do you think he did it?"

Bret shrugged the shoulder again. "I don't really think anything," he said. "I just wonder. You want to go back now?"

"Yeah," I said. "Yeah, I do."

I was finding that I was suddenly weary of the dark weight that seemed to be settling on me as my attention focused on these murders. I wanted to go back to vacation mode. Blue and Mac were at the swimming hole now, in the sunshine. I wanted to be there, too.

"Want to go swimming?" I asked Bret.

He shook his head and smiled, as if his mind were elsewhere.

We bounced along the dirt road in silence. A dusty blur ahead of us announced itself by loud engine noise to be a growling diesel pickup, coming our way. As it drew alongside, both Bret and the driver of the truck slowed to a stop. Looking across Bret, I could see the solitary driver, a man of roughly sixty, with a jowly face that reminded me of a bassett hound.

"Well, hi, Bret. What the hell are you up to?" The words were ordinary enough, but the man's voice had an odd whining twang, and this typical greeting had the sound of a complaint.

"Just taking Gail, here, for a drive. She's visiting from the coast with her husband and son." Bret's voice was noncommittal.

"I thought you'd be out investigating who killed Cole and Lorene. Or are you guys sure Lonny did it?" The man's whiny voice had an avid note as he said this.

"Ask John Green, not me, Joe. He's the detective."

"I know you don't know shit. That's for sure." Joe spat some tobacco juice out the window of his truck, narrowly missing the Jeep. "And you wouldn't tell me if you did know. I'm headed down to the saleyard to talk to Blake."

Bret put the Jeep in gear and inched it forward. "See you, Joe."

"Who's that?" I asked, as we drove on.

"Joe Evans, the brand inspector. He doesn't care for me much."

"I could tell. Why's that?"

"Oh, our work overlaps a bit. He was born and raised up here; his dad owned one of the biggest local ranches. He thinks his shit don't stink. He also thinks I'm a little pipsqueak of a recent hire that should lick his boots." Bret shrugged.

The Jeep moved down the road more slowly than usual. Bret's eyes were on the hills to the left, where the old stone house was visible. As we drew even with it, I could see a woman riding a horse in the arena, schooling the animal around some blue oil drums in the classic cloverleaf pattern of barrel racing.

"Donna Wells," Bret said. "Mind if we stop and say hi?"

"Go ahead," I told him. For all my desire to be back with Blue and Mac, I had enough curiosity about the woman who was said to be dating Cole Richardson to want to meet her. And I had an idea that Bret had something up his sleeve.

Bret turned the Jeep down the graveled driveway and drove up to the arena, where a blond woman was bending a sorrel horse around a barrel at the walk. Over and over again she took the horse's head and made him give. All nice and easy and gentle. The woman looked about my age—mid-forties. Judging by the snaffle bit in his mouth, the horse was relatively green.

Bret and I got out and walked up to the fence. Donna Wells stopped bending her horse and rode to meet us.

"Hey, Bret," she said, and regarded me with mild curiosity.

Bret made introductions and I mouthed a polite greeting, while covertly studying the woman.

Donna Wells looked tough. That was my first impression. From the lean, whip-hard body to the too obviously dyed blond hair to the bright makeup, she had that hard, western cowgirl aura that I was only too familiar with. On closer inspection, though, her eyes were intelligent. Her expression was stern, though.

Donna Wells didn't mince any words. "I heard you guys arrested Lonny Peterson."

"That's right," Bret said.

"John Green sure he did it?" Donna sniffed.

Bret shrugged. This, I reminded myself, was the woman who'd been dating Cole.

Bret's eyes were still on Donna's face. "What do you think?" he asked quietly.

Donna continued to meet Bret's eyes. Her colt mouthed his bit, and she reached one hand down to stroke his mane. "I don't know," she said slowly. "I have a hard time believing it was Lonny."

"Any ideas?" Bret asked.

More silence. Then Donna shook her head. "Not exactly. But Cole was worried about something. I could tell."

Bret studied the ground and took his time. "Any thoughts on who or what Cole was worried about?" he asked, looking up and meeting Donna's eyes again.

Donna stroked the colt and sighed. "Cole was a really private person." For a second she looked like she would tear up, but then blinked and went on steadily enough. "We were talking about getting married, but there was still a lot I didn't know about him. He never told me exactly, but the last time I saw him, he was upset about something, I could tell. I asked him what was wrong and he said it was a business deal. I asked him if I could help, and he switched on the charm, which was his way. Just said I could come with him to the coast next week. And then acted like it was no big deal. But next week never came for him."

Bret took this in. "Do you think he was killed over this business deal?"

"I have no idea," Donna said, and looked down at her colt's mane.

"What about Lorene?" Bret asked quietly.

"Lorene was a good person," Donna said. "Everyone liked her. Unlike that ex-husband of hers." She sniffed. "I know she and Lonny were fighting because she was seeing Kevin, and I still can't imagine why the hell she wanted to start things up again with Kevin. She was well rid of him, in my opinion. But I can't picture Lonny Peterson killing her or Cole."

Bret nodded. I stood silently by the fence and mentally seconded this statement.

Donna looked like she'd had enough talking. She blinked her eyes and tightened her jaw. I saw her hand shift on the reins and the sorrel colt edged sideways.

Bret straightened up. "Thanks, Donna," he said. "We'll see you."

"Nice to meet you," I said. "I'm sorry for your loss."

Donna turned her horse away and Bret and I climbed back in the Jeep. "I wonder what all that means," I said as we bumped slowly down the driveway.

Bret was following some track of his own. "Blake," he said, half to himself. "Blake must know. Or have some idea, anyway."

"What do you mean?" I asked him.

Bret turned back onto the dirt road before he answered. "I've heard rumors," he said slowly, "that Cole was involved in some underhanded stuff. I think that's what Donna was talking about."

"What sort of underhanded stuff?"

Bret shrugged, the same one-shoulder twitch I'd seen earlier. "Cole had too much money," he said.

"What is that supposed to mean? Cole was a livestock auctioneer, right? Are you trying to tell me he was a drug dealer on the side?"

Bret didn't answer me, just drove down the road, his eyes on the middle distance. "I'd heard he had a house on the coast," he said, again as if he were talking to himself, "but he kept pretty quiet about it. And that's odd, too."

I was getting frustrated. I didn't understand any part of this conversation. Grabbing onto a phrase that made sense, I demanded, "House on the coast? Where on the coast?"

Lonny's pasture gate was approaching, and Bret brought the Jeep to a gentle halt. For the first time, he met my eyes. "Where?" he repeated. "Why, right near you. Or so I've heard."

Chapter 9

BY THE time we got back to camp, I'd pried a few more answers out of Bret. Not many, but a few. He'd heard that Cole had a house in the hills behind Monterey Bay, in my very own neighborhood, in fact. And that there had been rumors before that Cole was making more money off the livestock auction than he had a right to.

When I asked how, Bret declined to comment. Since we were nearly back, I didn't press him. Besides, I knew from long experience that getting Bret to part with information he didn't care to part with was as difficult as mouthing a recalcitrant pony.

"I'll let you know when I know more," was all he would say.

"All right," I said. "When will I see you?"

"If they set bail on Lonny, I'll bring him back home. That'll be day after tomorrow. I'll talk to you then."

"All right," I said again. "Anything I can do in the meantime?"

"Yep." Bret grinned. "Stay out of trouble."

"Will do." I smiled back and got out of the Jeep. "Right now I'm off to go swimming. See ya."

As soon as Bret was gone, I climbed into the camper and put on my bathing suit. Tying a sarong around my waist, I stuck out my tongue at my ample self in the mirror, grabbed a towel,

slipped my feet into huarache sandals, and started down the path to the swimming hole.

It was midafternoon and the sun was high and warm. The path followed the creek and the soft, silky-looking water was inviting. I could hardly resist wading my way along. But I stuck to the path and hurried, eager to reach Mac and Blue.

I heard them long before I saw them. Mac's shouts and laughter and Freckles' barks echoed off the granite-strewn banks of the gully. I followed the path as it wound down the steep slope and emerged behind a large rock on the side of the biggest pool. Blue sat on a smooth piece of granite that sloped down into the water, his legs immersed to his knees. Mac, wearing a life jacket, floated about the pool in an inner tube, laughing at Freckles, who paddled after him.

"Well, hello there," I said.

"Mama!" Mac shouted in delight.

"Hi sweetheart," Blue greeted me.

In a second I was engulfed by family life once more; my odd afternoon trailing Bret around as he engaged in some sort of faux-investigation vanished from my mind almost as if it had never been. Almost. Periodically, as I alternately dipped myself in the (quite chilly) water of the creek and sunned on the rocks, a face would reappear in my mind. Blake Richardson, Kevin Moore, Justin Roberts, Joe Evans, Donna Wells. And Bret's idea that Cole had been up to something nefarious stuck in my mind.

I tried to decide if any of the people I'd met struck me as a killer, and found that I honestly couldn't picture it. And yet I knew enough of life to be sure that many unlikely people had been moved to murder under extreme circumstances. And after all, wasn't that just what the local detective was theorizing about Lonny? That he'd killed his girlfriend while in the grip of jealousy? Such things had happened throughout history, as I very well knew, and yet I did not believe, not for one second, that Lonny had done this.

But if Lonny was innocent, someone else was guilty, and it seemed entirely possible that it was one of the five people I'd met today. If so, which one? What had Bret said? "Blake must know?" I pondered on that awhile. Had Bret meant that Blake must have known about whatever Cole was up to? And did that mean that Bret thought Blake was the likeliest suspect? I found that I wanted to see Blake Richardson again, wanted to use whatever intuitive skills I possessed to sense whether I was facing a killer.

But there was nothing to do about it now. I sunned myself on the gray rock shelf and watched a redtail hawk make circles in the sky above. Faintly his *scree scree scree*, echoed down into the gully.

Eventually Mac wearied of paddling in the water—although not until he was almost blue with cold and his fingers and toes were as wrinkled as prunes—and we all trooped down the path through the green fields toward camp. The stream splashed and sparkled along next to us, gurgling a spring song. Back at the camper, after a snack, Mac and Blue stretched out on the bed to nap, or wrestle, depending on the moment.

I settled myself in a chair outside in the shade, with a book in my lap. But I didn't read. Instead I stared out over the meadow, watching the silvery, serpentine curve of the creek, listening to the meadowlarks trill. I watched our three saddle horses in their corrals: particularly, I watched Gunner.

When the pasture horses ambled in an hour later for a drink, and to socialize with their new neighbors, I was still watching my old blaze-faced bay buddy. I studied him, and then turned my eyes to little palomino Sunny, who regarded me right back with his steady, quizzical gaze.

Why not? What moment would be better?

Fetching a halter, I walked up to Sunny. The horse took a halfhearted step away from me, but stopped when I said whoa, and I walked into the space to the left of his shoulder, patted his

neck, and flipped my leadrope around his throatlatch. Haltering him, I led him over to the corrals and opened Gunner's gate.

Gunner's ears came up and he stepped out of the pen smartly, trotting over to the herd of pasture horses. I listened to the nickers and occasional squeals as Gunner got acquainted with his new buddies; at the same time I shut Sunny in Gunner's corral.

"Your turn to be my saddle horse," I told him. "Gunner gets a vacation."

Sunny regarded me imperturbably, ears forward, eyes on my face. An intriguing horse.

For his part Gunner was loping a wide circle in the meadow, head up, tail flagged, as Smoky galloped along with him. Twister, Danny, and Chester watched the play with calm eyes, their tails switching lazily.

I smiled. Gunner looked about as happy as a horse could look. I couldn't see any bob in his stride; he appeared completely sound. Adrenaline and *joie de vivre* were definitely doing him good. Pinning his ears, he nipped playfully at Smoky, who scooted away. No doubt in my mind that Gunner was going to enjoy his time in the pasture.

I could see Mac's face peering from the camper window. "Mama! You turned Gunner loose."

"That's right," I called back. "Gunner's gonna live out here with Twister and Danny for a while. I'll ride Sunny."

Mac took that in. "I'll miss Gunner," he said.

"So will I. But doesn't he look happy?"

Gunner loped by the campsite, throwing in a buck for good measure.

Mac laughed. "He does."

"This will be good for him," I said firmly.

"All right," Mac said, and I saw his face disappear back into the camper.

I watched as Gunner took a long drink of water from the

trough and then joined up with the other pasture horses as they fanned out across the meadow.

Plumber nickered plaintively after him, and I sighed. Plumber and Gunner had been companions for many years. Walking to the fence, I stoked Plumber's cocoa brown neck.

"You'll get used to it," I told him. "You've got Henry and Sunny."

And in a minute, Plumber did turn his attention to snuffling Sunny over the fence, checking out his new comrade. A few squeals and nips indicated that Plumber meant to be boss. Sunny, I noticed, did not respond in kind and seemed content to move away, not arguing with Plumber. Looked like my new horse had no need to be dominant.

My new horse... For a moment I gazed at the stocky palomino gelding in mild confusion, wondering how this had all come about. I hadn't meant to acquire a new horse. Had I? And yet, here he was. And here I was, taking him on. Sometimes life seemed to move me in ways I hardly understood. In theory I was in charge of whether I acquired another horse. But in practice?

The sun was sinking low in the sky when I finally quit watching the horses and went back to the camper.

Blue and Mac had built a campfire and were sitting around it. Mac poked the flames from time to time with a long stick and Blue was pouring marinade over some pieces of chicken in a dish on the wooden table.

"Care for a drink?" Blue asked, smiling at my approach.

"Sure," I said, and settled myself in a chair.

In a minute Blue emerged from the camper, margaritas in hand. "Cheers," he said.

I took the first sharp, strong, lemony-sweet sip and sighed, staring out over the quiet meadow at the distant shapes of the pasture-horse herd.

Blue followed my eyes. "To Gunner," he added. "Your old buddy looks pretty happy."

"He does," I agreed.

"How about you?"

"I'm happy for him. But like Mac said," I smiled at my little boy, "I'll miss him. At the same time, I'm interested in Sunny. A new horse is fun. And I think we'll all have fun riding together, now that we have three sound saddle horses. We've given up a lot of rides because Gunner was too sore to go."

"That's true." Blue's eyes creased humorously at the corners. "And you can actually get on this one."

"Right you are. He's just the size for a stout middle-aged lady." And I smiled back at Blue.

I took another sip and my eyes wandered over to the corrals where Sunny's bright gold shape stood calmly, one hind leg cocked in a resting pose. Clearly he wasn't stressed about being penned up. I had the impression this horse didn't stress about anything much.

I smiled at Blue and lifted my glass again. "Here's to Sunny. And the future."

Chapter 10

THE NEXT morning passed in the quiet way of a leisurely vacation. We hiked and read and went for a ride. I struggled to forget the reason for our host's absence and just have a good time. It wasn't easy.

About noontime, Blue suggested we go to town for lunch.

Carson Valley didn't turn out to be much of a town. A small café perched on the corner where two roads met, with a bar across the street. The saleyard sat up on the hill behind the café. Next to the bar was a simple playground with swings and a slide.

The playground immediately caught Mac's eye and he demanded to go "check it out." Blue insisted on having lunch first, and the promise of French fries was sufficiently alluring to quiet Mac's protests.

We parked in front of the café and the three of us filed in the narrow door. The place was tiny and crowded with red leather booths. I could see a few guys at the counter, every single one of them wearing a ball cap and Wrangler jeans. Male voices sounded from a few booths over. I glanced quickly in that direction and away. Surely these were the same men I'd seen yesterday at the saleyard. I tried to remember all the names. Blake Richardson,

Kevin Moore, Joe Evans, and Justin Roberts. None of them was looking my way. I was mostly hidden behind Blue's tall frame. No doubt they'd spotted him as a stranger and gone back to their conversation.

Hastily I tugged Blue and Mac into the booth next to theirs, positioning myself with my back to the men. I could hear them clearly. But they couldn't see my face.

The whiny, sing-song voice belonged to the brand inspector, I thought. "Goddamn that Lonny sure looks stupid now. Why the hell did he think he could get away with this? Damn. I bet you'd like to have a go at him, huh, Blake."

Some silence. Then the quiet, somewhat somber voice of Blake Richardson. "What would I do? Kill the guy? It's up to the courts."

"Hell, no." The mocking, slightly slurred voice I associated with Kevin Moore. "If the courts don't do their job, I'll do it for them. That bastard won't be running around here. Not after he killed Lorene."

More silence. Then a calm, in-charge voice. This must be Justin Roberts, the neighbor. "We don't know what's going to happen. There's no use worrying about it. We need to help Blake to keep the sale going. You have any ideas, Blake?"

"Not really. I still can't believe this is happening, to tell you the truth. But I do need to keep the sale alive. Otherwise I'll starve."

"No problem." Joe's voice. "We'll just find you another auctioneer to cover for a while. And somebody to do the books."

"Do you know anyone?" Blake again.

And a cheerful, gray-haired waitress showed up at our table. The subsequent ordering of lunch drowned out the conversation behind me. Mac decided he wanted a hot dog with his French fries. Blue wanted chili. I hastily ordered a salad and tried to eavesdrop some more, but the men seemed to have moved on to talking about cattle.

"Goddamn secondary brands all over the place," said Joe Evans, seeming to be at the end of a tirade.

Blake spoke in a quiet tone. "That was never my department. I don't know what my brother would have done. And I can't ask him now." There was a heavy note of finality in the voice, and something else, something I couldn't place. Anger, maybe.

"Don't worry about it, Blake," Joe sounded apologetic. "I know you've got enough on your plate."

"Damn right." Kevin Moore's voice. I could hear a shuffling, as if he were standing up. "If there's anything I can do to help, buddy, let me know. I got to go fix a hole in my south pasture fence. That damn black bull went through it the other day."

In another moment the man was edging past our booth, pausing, in the way of locals everywhere, to glance curiously at the table of strangers. I saw his eyes narrow as they rested on my face.

"Well, howdy, ma'am." The drawl became more pronounced. "Didn't I meet you with Bret Boncantini yesterday?"

"You did," I agreed. I debated whether I should add some polite formalities and introduce my husband and son, and decided the hell with it. I didn't like this guy. I looked down at my glass of water and willed him to move on.

Blue, never particularly nosy, met Kevin's eyes with a quiet, noncommital gaze, and Mac, in the way of children, stared openly. After a minute Kevin nodded and walked past us. I could feel the silence at the table behind me. They'd all heard Kevin's words.

Fortunately the waitress brought our meal at this point and Blue and Mac were absorbed immediately into the delights of a café lunch. I kept my back to the men in the booth behind me and ate my salad. If they did any further talking, it wasn't audible to me.

When we'd finished our lunch, Blue and I yielded to Mac's request to check out the playground. I glanced over my shoulder

as I stepped out the café door and saw three pairs of eyes resting on me very speculatively. The men in the booth were definitely aware of my departure.

Once outside, I stared up a narrow graveled drive to the red barn that was the auction building. A restless spring wind blew the grass along the drive in great bending swells, rippling green to silver. Bright, puffy white clouds raced across the sharp blue sky. Mac tugged at Blue's hand.

"Can you take him to the playground?" I asked Blue. "I want to walk up and see the auction yard."

"Sure," Blue said.

The two of them crossed the street hand in hand. I wandered up the hill toward the saleyard. No one seemed to be around. The wind blew my hair across my face in chilly little flurries. I could see cattle standing in pens behind the auction barn. I walked in that direction.

Heads down, eyes half-closed, some white-faced steers drowsed behind the metal bars of a corral fence, their tails switching at flies. I stared at the cattle, half seeing them, half remembering the last time I'd been to a livestock auction. The crowding pens full of animals, the cowboys hollering as they moved critters in and out of the sale ring, the horses charging and excited, the cattle milling. Unlike this quiet moment, that scene had been so full of action that it had been hard to follow everything.

I walked slowly down the alley that led to the sale ring, picking my way between piles of manure, passing the large scales on the left. This was the way the cattle and horses would travel, pushed by the ring men, on their way to be sold. The sale ring was empty now, the auction barn quiet, the bleachers deserted, but on sale day the place would be full of people. I remembered watching the horses sell at the auction I'd visited—for the first and last time in my life.

The sight of the poor animals, many old and crippled, some young and obviously unbroken, being run through the sale only

to be bought by the kill buyers, who would ship them to Mexico or Canada to be slaughtered for pet food, made me feel sick. The old horses, particularly, broke my heart. Some had been good animals, had worked hard for many people, only to be thrown away at the end of their lives like used-up sporting equipment.

I thought of Gunner and Danny and Twister, who all would have been sent to the sale by an owner who had no feelings for horses who were no longer sound and useful, and quick tears welled up in my eyes. All the many, many horses in the world who were just as kind, willing, and deserving as my geldings and had no one to take care of them-—it didn't bear thinking of.

I felt a flash of admiration and respect for Kate, who seemed to be trying to do something about this sad state of affairs. Sunny, my new little horse, had been rescued from this same saleyard. And here Cole the auctioneer and his sister, Lorene, had met their end. I walked across the ring, out the gate on the far side, and peered in the window of the office part of the building.

I could see the yellow crime-scene tape, also the dark stain in the middle of the room. I closed my eyes and turned back to the ring. For a second I stared blankly. Somehow the place looked familiar. But I was sure I had never been here before.

For a moment the memory eluded me, and then I recalled the dream I'd had the night before we'd left home to come up here. The dream about an auction. This was the same place. I was sure of it. Had I dreamed of Cole?

All I could picture was a slim, dark man behind a microphone. In this building. I took a sudden breath. I had dreamed of this place the night Cole was murdered. What could it mean?

I did not see myself as psychic. But I was completely certain I had seen this saleyard in my dream before I had ever seen it in life. Lost in this thought, I failed to notice the man until he was right in front of me.

"What are you doing in here?"

Blake Richardson looked half-angry and half-suspicious.

Yesterday I had thought I would like to face this man again and see what my intuition told me. Suddenly I wasn't sure if this was a good idea. Blake's light blue eyes, startling in the olive-skinned face, were fixed on me, and his tense expression demanded an answer.

"I'm sorry," I said. "We're staying with Lonny Peterson, and he's accused of these murders. I was curious."

It was the truth, more or less. I could hardly tell this man that I thought I'd seen the place in a dream. He'd think he had a lunatic on his hands.

Blake Richardson didn't seem to think much of my explanation. "The people who were killed were my brother and sister," he said flatly.

"Do you believe Lonny killed them?" The words just popped out of my mouth; I hadn't meant to say them.

Blake stared at me. "Why do you say that?"

"Lonny's my friend. I've known him a long time. I don't believe he'd kill anyone. Not like that."

Blake shrugged slightly. "The evidence points to him. The cops think he did it. What else am I supposed to think?"

For a moment we stared at each other.

And then he said, "You are trespassing." The tone was quiet and calm, but I could feel something—anger, turmoil, resentment…something strong—underlying the words.

"I'm sorry," I said again. "I'll be going."

And he took a step toward me.

For a second a visceral fear surged up my thoat. I stumbled quickly backward and toward the nearest gate.

Blake Richardson stopped and watched me go. I had the notion he was amused.

I didn't hesitate or try to figure him out any further. I didn't know if I'd been facing a killer or someone who was angry because his family had been murdered. I could feel the anger but I

didn't know what to make of it, and I had the sense I wasn't likely to find out. I'd had enough. I wanted out of there.

In another two minutes I was down the hill collecting Blue and Mac from the playground, and we were all on our way back to camp, where we passed a peaceful afternoon at the swimming hole.

But I couldn't forget Blake's face. Or my dream.

———

That night I tossed and turned, unable to sleep. The coyotes sang and the moon shone white on the quiet hills. I peered out the window, but no mysterious horseman appeared. The pasture herd, including Gunner, was elsewhere. Only the quiet, resting shapes of the saddle horses were visible in the corrals, light-colored Sunny easiest to spot. Nothing else. But still I rolled from side to side, restless and wakeful, listening to Mac's and Blue's gentle breathing. Sleep was a long time in coming.

Chapter 11

EARLY THE next morning, we got a visit from Kate. I was out feeding the horses when an older, light blue pickup drove in the ranch road. I recognized the slim, auburn-haired woman who got out of the driver's side as Kate. Her brown-haired daughter, who appeared to be about ten, climbed out of the passenger-side door and stood behind her mother. Both of them stared at Sunny.

After a moment, Kate turned to face me. "I noticed Sunny wasn't with the pasture horses and came to see what was up." As before, her tone sounded faintly belligerent.

"Looks like I'm keeping him," I said. "That is, if he's mine to keep."

Kate studied the horses in the corrals and then looked back at me. "Lonny said that he would give him to a good home, that you gave all your horses the best. He told me about Twister and Danny, how you took care of them after they got hurt. I trust Lonny. So I said he could give Sunny to you."

"All right," I said.

"I usually have people sign a contract saying that they'll return the horse to me if they don't want him anymore, but Lonny said I could trust you."

"You can, but I don't expect you to know that."

"Are these your horses?" Kate asked, looking at Plumber and Henry.

"Yes," I said. "Also Twister and Danny and that blaze-faced bay gelding who's out with the herd now. His name's Gunner."

She nodded. "I'm not worried about Sunny."

But I noticed she still looked tense. "I hear Lonny gets charged today," she said.

"That's what I understand."

"Lonny didn't kill those people." Kate sounded almost too emphatic.

"I agree." I watched her carefully. "Any particular reason you say that?"

Kate met my eyes. After a while she spoke. "It's complicated," she said slowly. "I was at the saleyard on Saturday. Right after the sale. I was out back, looking at the horses in the pens. I sort of sneaked back there. The Richardsons don't like me. They don't want me looking around, seeing what they're up to. If they caught me, I'd be barred from the auction for sure. And I need to be able to go to the sale." Her fierce eyes were still holding steady on mine.

"But you were there," I prodded. I felt a little shiver of anticipation. Kate knew something. I was sure of it.

"Yeah, I was there. Nobody was around. I was looking at this poor skinny black mare, wondering how I could get enough money to buy her from the kill buyer. Then I saw Blake coming from the direction of the cattle pens and decided I'd better leave. I headed back out by the office. And then..." She hesitated. "I didn't think anything of it at the time. But now I wonder."

"What?" I demanded.

Kate shook her head. "I'm not sure," she said.

"Tell the cops, whatever it is," I advised.

"It won't help." Kate jerked her chin to one side. "I didn't really see anything. I'm not going to talk about it. Not until I understand it better."

"I still think you'd be better off if you told the cops everything you know or even suspect. At least tell them you were there about the time Cole and Lorene were killed."

"And have them suspect me?" Kate gave me a dark look. "I'm not real popular around here. I don't know why I'm telling you. But I know Lonny didn't do it."

I stared at Kate. Her daughter had wandered over to the horse corrals and was petting Sunny, who nuzzled her in a friendly way. Looking in the direction of the camper, I could see Mac puttering in our direction, clearly curious about the little girl. Kate followed my eyes and seemed to make a snap decision.

"Come on, Ruth," she said. "Time to go to school. Take good care of Sunny," she added to me. "I know you will."

"I will. Take care of yourself," I returned, a little guardedly.

And Kate and her daughter climbed into the old truck and drove away.

———

The rest of the day I kept an eye out for Bret, but it wasn't until evening, when dinner was done and Mac was roasting marshmallows, that the sheriff's sedan pulled up in front of our camp and Bret got out of it.

"Where's Lonny?" I asked, as soon as Freckles had settled down and Bret had been greeted.

"I took him home." Bret said. "He said he'd see you tomorrow."

"Oh." I took a breath. "Of course. He must be tired."

"He probably needs some time," Blue said, in his quiet way.

"There was no problem with the bail?" I asked Bret.

"Nope. It was set at one million. Lonny got it done."

"Now what?" I asked, as Bret sat down in a chair by the fire.

"Now Lonny's lawyer works on his defense."

We all were quiet, watching the flames. After a minute, I recounted my visit from Kate and what she'd said. Bret's eyes narrowed as he listened.

"So what do you think?" I asked him. "Did she see someone? I think that's what she was implying."

Bret twitched his shoulder, in that one-sided shrug I was getting to know. "Hard to say. She didn't really tell you much of anything except that she was there."

"And that she saw something." I repeated. "Don't you guys want to ask her some questions?"

"We should," Bret agreed. "She's right about one thing. No one around here feels real friendly toward her."

"What about you?" I said. "You could ask her what she saw."

Bret looked at me. "You don't get it, do you? If I go around asking people questions, like I'm investigating behind his back, John Green will have my butt. I'll be out of a job."

"Oh." I said. "So you'd have to tell John Green that you heard she was there and then hope he'd question her?"

"Right. And he wouldn't be real friendly to her."

I shook my head. "I bet she'd sull up and refuse to even admit she was there." I sighed. "What do you think?" I asked Bret in frustration. "I know you don't think Lonny did it. But if he didn't, who did? And why?"

Bret took a while to consider this. His eyes went to Blue, who was watching Mac. Mac was browning his marshmallow and seemed uninterested in our talk.

At last Bret turned his face in my direction. "Between you and me," he said, with a questioning note in his voice.

"We won't repeat it," I agreed.

"I think it has something to do with what Cole was up to."

"What Donna was talking about?" I asked.

"Yeah."

"Why Lorene, then?" Blue asked quietly.

"Hard to say. Maybe she knew what was going on. Maybe because the guy planned to set Lonny up for a jealousy motive and wanted to make Cole look incidental. So nobody would investigate Cole and his doings."

We took that in.

"If it's true, " I said, "that's wicked."

"What's wicked, Mama?"

All our eyes shot to Mac, who had eaten his marshmallow and was quite obviously paying attention.

Stymied, I floundered, "Some people are wicked, sweetheart."

"Is this about Lonny?" Mac demanded.

"Yes."

"And why he's not here?"

"Yes. But he's back now. We'll see him tomorrow."

"Good." Mac smiled and seemed distracted from the subject at hand. "Can I have another marshmallow?"

"Sure."

The adults sat silently while Mac put a fresh marshmallow on his toasting fork and poised it over the fire.

"I'm off tomorrow," Bret said at last. "I'll try to swing by here. Maybe in the early afternoon. And maybe we can go for another little drive."

"To the saleyard?" I asked.

"Sure, if you want. And to visit Donna."

"All right," I said.

"Mac and I will go swimming." Blue grinned.

"All right then." Bret stood up, scratched Freckles behind the ears, and said his good-byes.

The night passed peacefully. The coyotes sang, as usual, but no mystery horseman disturbed my sleep. I woke once to see the quiet shapes of the pasture horses, cropping grass in the moonlight. Picking Gunner out by his white blaze, I watched him awhile and then drifted off to sleep, feeling content. Morning showed our three saddle horses waiting for breakfast in the corrals, little bright gold Sunny seeming a settled part of the group when I distributed flakes of hay.

The desire to go to Lonny's house and see how he was doing plagued me, but I resisted it. Lonny had been through a lot;

he probably needed some space. Visitors might not be what he wanted right now.

But about midmorning a beige four-wheel-drive pickup came down the ranch road and parked by our camp. Freckles woofed and Mac came scrambling down the camper steps in excitement.

"That looks like Lonny!" he said.

Blue was out gathering firewood; I raised my head from my book, aware of a knot of dread in my stomach. Somehow the thought of a cowed, beaten, grief-struck Lonny was beyond bearing.

To my relief, though he looked old and tired, Lonny was matter-of-fact and steady, very much his old self, though the sparkle in his green eyes was dimmed.

"How are you doing?" I asked, hoping my anxiety didn't show too much.

"I'm okay," Lonny said simply. "How are you guys?" And he smiled at Mac.

Faced with this awe-inspiring figure that he had so looked forward to seeing, Mac went suddenly shy and hid behind my back.

"We're doing good," I said. "We've been swimming and riding a lot. I'm enjoying Sunny. And I turned Gunner out with the other horses. Everybody seems fine."

"Good," Lonny said. "Will you take Sunny back to the coast?"

"Sure. If it's okay with you. Kate visited yesterday and gave me her okay."

"Did she?" Lonny smiled his tired smile. "She's sort of an odd duck, but she means well. I think the little yellow horse is a good one. I rode him a few times. I'm glad you like him."

"Kate said something else. She said she was at the saleyard," I glanced down at Mac, "that evening. She saw something. She wouldn't tell me what. Maybe she saw someone."

Lonny met my eyes. "There must have been someone, all right. Because it damn sure wasn't me."

"I know," I said. "Bret knows it, too. It's only this detective who thinks you're guilty."

Lonny's mouth twisted ruefully. "John Green. Who has been a detective in this county for thirty years. He doesn't know me. All he knows is, the evidence damns me. And that's good enough for him."

"Get a good lawyer," I said. "Hire a private investigator. Find out who did it."

"Maybe," Lonny said, and looked down at Mac with that weary smile. "Should we go for a ride? I haven't ridden Smoky in a week."

"Can we, Mama?" Mac begged.

"Sure."

And in another minute we were all out at the corrals, catching and saddling horses. Just another day on the ranch.

Chapter 12

BRET ARRIVED early that afternoon, true to his word. Blue and Mac and Freckles were down at the swimming hole. Lonny had departed for home, after riding around the ranch with the three of us. I was the only one left in camp, sitting outside under an oak tree, reading a mystery by Laurie King. I looked up at the approach of the blue Jeep.

Bret climbed out of the driver's side and sat down. "I just went by and had a chat with Lonny," he said.

I put my book down. "What did he say?"

"I wanted to get his story. Off the record. Starting with that barbecue he had on Friday night."

"So, what did he say?"

"He said he invited a few people over. Lorene and Cole and Blake, Donna, Justin, another guy you haven't met named Rusty Porter. He's a local rancher who goes team roping with Lonny. And Kevin showed up, uninvited, and joined the party.

"Lonny says that at some point in the evening, after lots of beer had been drunk and all the steak had been eaten, Kevin started coming on to Lorene.

"Those were his words. 'Coming on.' I wasn't there, so I don't know if Lorene was flirting with Kevin or it was all on Kevin's

part or what. All I know is that Lonny said that it pissed him off and he told Kevin to get the hell out of his house. Kevin left, I guess, but not without doing some hollering at Lonny. Lonny says he told Kevin to go to hell and leave Lorene alone, or some such thing.

"Apparently Lorene didn't like this, because shortly after Kevin left, she left, too. And all those guys heard her tell Lonny, 'You don't own me.' She was thoroughly pissed off, by all accounts.

"So, according to Lonny, the rest of them hang around for a while, and then they all leave."

I was thinking fast. "What about the gun?"

"That's what I asked him," Bret agreed. "Lonny said that he has no idea when the gun was stolen. It was in an unlocked drawer in his bedside table." Bret grinned. "You'll find a gun like that in virtually every house in this county. It's why we have so few break-ins.

"Lonny said he hadn't looked at the gun in months. It was no secret that he had it. Lorene certainly knew. I asked if it could have been taken that night and he said, sure. The bathroom is across the hall from the bedroom and both are out of sight of the living room and deck, where the party was going on. Everybody used the bathroom. Anybody could have stolen that gun."

"And anybody who was planning this crime would have had the sense not to get their fingerprints on it."

"Yep," Bret said. "But it could have been anyone who was in Lonny's house for the last few months, including someone who walked in while he was gone, since he doesn't keep it locked. So it doesn't narrow our suspect list down much."

"Did Lonny tell you what happened at the auction yard on Saturday evening?"

"Yeah. There wasn't much to tell. Saturday was always sale day and Lonny usually picked Lorene up after the sale and took her to dinner. He drove out there about the usual time, about six o'clock, and walked in the office. He wasn't sure if Lorene was

still pissed at him or not. He said he stepped in the door, saw her working at her desk, and asked if she wanted to go to dinner. She made a short answer, said she still had a lot to get through, and Lonny figured she was still mad at him. So he said, 'See you later,' and left. And that's all he knew until Blake called him around ten o'clock that night and told him what happened."

"So Blake found the bodies?"

"That's right," Bret said ruminatively. "Blake found them. Right around seven o'clock."

"Does Blake inherit the business?"

"Looks like it," Bret said. "Neither Cole or Lorene had kids."

"Will he keep on running it?"

"Hard to say. Cole ran that business. He wasn't just the auctioneer. Cole was the oldest son. His dad, Ron, ran the business before him. Lorene did the books and worked the front office. Blake is really just a yard man. He takes care of the physical operation, handles the livestock, does the feeding. He's gonna need some help if he wants to keep it going."

"Does Blake live there?" I asked.

"Yeah. He's got a house out back of the yard. Cole and Lorene both lived near there, but not on the place."

I was thinking. "Did Lonny see anyone while he was there that night? Blake? Kate? Cole? Kate said she saw Blake back in the pens."

"Lonny said he didn't see anyone. But he wasn't looking. He was thinking about Lorene and wondering if she was mad and he wasn't paying attention to much of anything else. He didn't see Cole. Cole had a separate office. Lonny doesn't know whether he was in it or not. He doesn't remember seeing Blake or anyone else."

"Where were the bodies found?"

"On the floor of the main office. Cole's body was near the doorway to his office. Shot nice and neat, through the heart, both of them."

I remembered the dark stain on the floor that I'd seen, and winced.

"Did anyone hear the shots?" I asked Bret.

"Blake isn't sure. He was questioned, of course. He says he might have. But people shoot up here all the time. Nobody pays much attention to the sound of shots."

"Yeah," I said. "I've noticed. I hear pistol shots a lot in the late afternoon. Somebody in that direction," and I gestured, "must have a regular target practice."

"Kevin Moore," Bret said.

"Oh."

We looked at each other. Then Bret got up. "I thought I'd take a little drive down to the saleyard and see how Blake's doing. Maybe visit Donna on the way back. Want to come?"

"Sure," I said. And a minute later we were bumping across the pasture in the Jeep.

"I had a look around the saleyard office yesterday afternoon," Bret said, half shouting over the engine noise and bumps and thumps. "Then I went up and had a look around Cole's house. Didn't find anything of interest. I hope to hell John Green doesn't find out what I'm up to."

"Uhm-hum," I said. "Bret, what is it you're looking for? What do you think Cole was up to?"

Bret waited until we'd crossed the pasture and I'd opened and closed the gate and gotten back into the Jeep to reply.

"I think he was skimming," he said at last. "In lots of ways. There's been rumors about him for years. Luke Barstow, he's an old rancher, he's been raising cattle in these parts since before I was born. He hauls all his livestock down to the sale at Atwater. I asked him why, once, and he said he didn't trust that damn Cole Richardson. He told me a few stories. It made me curious. So I kept my ear to the ground. And I heard a few more stories."

"What sort of stories?"

Bret gave me a direct look. His eyes were the same green-

brown they'd always been. I still had a hard time reconciling his lined face and silver hair with the young man my mind pictured.

"You gonna be able to keep this to yourself?"

"Yes," I said. "I might tell Blue. He can keep a secret. He's not chatty."

"I can see that. All right. Luke Barstow told me that Cole was doing lots of little things to make extra money. He'd get a truckload of cattle where the rancher wasn't quite sure of the count—happens all the time. It's hard keeping an accurate count of cattle that are being herded past you and crowded into the truck. The rancher would send the truck to the sale and tell Cole that he thought there were a hundred head on it. Cole would tell him there were only ninety-eight, and that was that. Nobody questioned it."

"What would Cole do with these cattle?"

"Rebrand 'em and run 'em through the sale. The brand inspector is his friend. If he told Joe not to worry about the secondary brands on the cattle, Joe wouldn't think twice about them. Whatever the cattle sold for would be pure profit for Cole. He wouldn't have spent a cent to acquire them."

"What are secondary brands? I heard that brand inspector talking about them when we were at the café Tuesday."

"If a guy buys a steer, say, that has the brand of the man who raised it, and then the buyer rebrands the steer with his own brand, the first guy's brand becomes a secondary brand. Normally you need to have a bill of sale that shows that the animal was inspected by a brand inspector at the time of the sale. That's to prevent theft. But Joe, the brand inspector, he'd take Cole's word on anything. And there were a lot of other ways Cole would cheat people, according to Luke."

"Like what?"

"Ranchers will drop cattle off a few days before the sale, sometimes. And sometimes a weak calf, that can't stand the strain of the hauling, will get sick and die. Luke said that Cole

would tell people that cattle had died when none did, and he'd keep those cattle, rebrand them and sell them.

"Another thing he could do." Bret's eyes were on the road. "As an auctioneer. He could sell cattle a little cheaper if he wanted, just pretend he hadn't seen the higher bid. A sale moves really fast, you know? 'Going, gone, sold at thirty cents a pound.' When maybe thirty-five cents was offered and ignored. Cole could sell cattle under market value and then resell them at the next sale and pocket the profit.

"And there was another way I think he was making money on cattle."

"What's that?"

"The time-honored western way." And Bret grinned. "Stealing cattle."

"Stealing cattle," I parroted. "You mean like, as in cattle rustling? Riding into somebody's pasture at night and gathering their cattle by the full moon?" My words brought an elusive image to mind.

"Yep." Bret grinned again. "Most of the ranches in these parts are pretty big. And everybody loses a few head from time to time. Cattle break a leg, or get sick and die, and wind up in a ravine somewhere and the rancher never finds 'em. So a little attrition, that's taken for granted. Luke Barstow reckons Cole was stealing cattle from him and every other rancher in these parts. Just a few head. Now and then. Not enough to make it obvious."

"Hmmm," I said. "I don't think this Luke liked Cole much."

"Nope. He didn't like Cole's dad, Ron, either."

"So, do you believe Luke?"

"I've been paying attention," Bret said. "There's other people who say the same. Most of it's said pretty quietly, because Cole was a big man around here. But it's said. I wondered about it. I heard that Cole built a fancy place on the coast on some land his dad left him. Like I said, I wonder."

I thought for a minute as the Jeep jounced down the road.

"Wouldn't Blake have to know?" I asked at last. "If Cole was doing all this and Blake was, is, what did you call it, the yard man?"

"You'd think so," Bret said. "I'm not sure, though."

We were nearing the saleyard now.

"Blake keeps to himself," Bret said. "He doesn't talk much. He sure never talked about Cole."

"Could Blake have been Cole's partner in all this stuff?"

"Yeah, I've thought of that." Bret looked ruminative. "And now Blake owns the whole place. I wonder how he's gonna manage it."

I said nothing. The Jeep bumped into the graveled parking lot of the Carson Valley Saleyard. I could see a small group of men standing out in the corrals, near the scales. Bret and I climbed out of the Jeep and strolled in that direction.

"Who's there?" I asked Bret.

"Blake, Justin, Kevin, Joe, and Rusty Porter, he's the one that was at Lonny's barbecue."

The five men formed themselves into a semicircle, flanking Blake, as Bret and I approached.

"Hey, Bret," Blake said.

The rest of them made noises of greeting in our general direction. I recognized the four already familiar faces. The stranger, a man with short, ginger red hair and a round face, must be Rusty Porter. I nodded and stretched my lips into a brief half smile.

"How's it going, Blake?" Bret responded.

"All right. I'm trying to get things organized so that we can have a sale on Saturday."

"The show must go on." Bret smiled sympathetically.

"Damn right." Blake's blue eyes showed a flash of something, I wasn't sure if it was anger or pain. "Justin knows a guy from Fresno who can do the auctioneering. I'm still trying to find someone who can run the office."

Justin Roberts said quietly, "Dave might know someone. I'll ask him."

"Thanks, Justin." Blake looked relieved. "I've got to keep this thing going, if I want to make a living."

Justin smiled. "We all know that. No one wants to see the sale disappear. We need you to keep it going. We need a place to sell our cattle. I'm glad to help if I can."

The words were kind and reasonable, the smile on the man's face was courteous and friendly. Why, I wondered, don't I like this guy? Some undercurrent that I couldn't place was bothering me.

The men around Blake looked reflective. Joe, the brand inspector, spat out some tobacco juice on the ground. "Damn it. Justin's right, Blake. We all need the sale to stay in business." Joe's voice had the whine I'd noticed before, his heavy-jowled basset hound face looked lugubrious, as if he nursed a perpetual grievance.

I didn't care for Joe, either. He seemed to have an unnaturally large chip on his shoulder. Hell, I didn't seem to care for any of these guys. Maybe I was becoming a curmudgeon in my old age. I was certainly developing hermit-like tendencies, anyway. My judgment about these men was undoubtedly colored by my general distaste for social intercourse.

My eyes drifted around the faces. Kevin Moore, I noticed, was watching Bret. After a minute, he spoke.

"So, Lonny's out on bail?" The voice was the same as I remembered it, slightly drawling, with a mocking undertone.

"That's right," Bret said.

"I hear you're visiting the man." This was directed at me.

"That's right," I echoed, meeting the cynical brown eyes.

"Tell old Lonny to watch his step," Kevin said. "He's gonna pay for what he did."

I watched Kevin carefully. The rest of the group did, too. His half smile never wavered. He kept meeting my eyes.

Biting back the angry retort that leaped to mind, I answered him quietly. "I'll be sure to tell Lonny exactly what you said."

Kevin Moore heard the edge in my voice. If anything, the faint smile grew more pronounced. He was baiting me. Prodding. Trying to get a response.

I closed my lips tightly and nodded.

Bret had taken in this little exchange and seemed to make a snap decision.

"Come on, Gail," he said, and headed for the Jeep.

I followed him, looking over my shoulder at the group of men. They watched us go with guarded eyes, not one of them registering any surprise at our sudden and unexplained departure.

"I didn't want you to get in an argument with Kevin," Bret said, when we were back in the Jeep and bumping across the parking lot.

"I wouldn't have," I said. "I could tell he was trying to provoke me."

"He does that," Bret said. "I wasn't sure what you'd do."

"Give me a little credit," I said. "I'm not as dumb as all that."

Bret just smiled. "We learned one thing. Blake does plan to keep the sale going. That's interesting." He was quiet for a minute, his eyes on the road ahead. "I really want to see Donna," he said at last.

"How are you gonna justify questioning her?"

"I'm not questioning her. I'm not on duty. I've known her a long time. I'm just visiting." Bret's lips twitched. "She just lost her boyfriend. Why wouldn't I visit her?"

"Good point." I subsided back in my seat. "Lead on."

And we bounced through the green hills toward the old stone house.

Chapter 13

BRET PULLED UP in front of Donna Wells' arena five minutes later. Donna was easy to spot, out by her barn, saddling a horse. Horses were no doubt her comfort in stressful times, just as they were mine. Of course, I thought, all horse people are like this. Look at the way Lonny had wanted to go for a ride on Smoky his first day home. Horses are an antidote for pain.

Bret ambled slowly in Donna's direction; I followed him. Donna saw us coming, but just kept on saddling her horse, which looked like the same young sorrel gelding that she'd been riding the other day.

When Bret was a few feet from the hitching rail, Donna paused, the snaffle bridle in her hands, and raised her eyebrows. "To what do I owe the pleasure?"

She didn't sound angry, just tough. As before, I was struck with the impression that this woman could probably out-cowboy most of her male compatriots.

Bret smiled at her. "I came to see how you were doing."

Despite the fact that I knew he had other motives, Bret sounded kind and charming, even to me. That was the thing about Bret. He could, when he wanted, make others feel appreciated.

Donna Wells was apparently not impervious to this charm. She smiled back.

"Thanks," she said. "I'm doing all right."

She and Bret regarded each other silently for a few moments. I could feel Bret waiting. Not pushing, just waiting.

"I'm probably doing better than Lonny." Donna shot a quick glance at me. "This must be really hard on him."

"It is," I said quietly, feeling that I was meant to say something.

"To be accused of killing Lorene…" Donna shook her head. "Poor guy."

"But you said you didn't believe he did it." I offered this tentatively.

Donna responded with force. "No way did Lonny do this. I damn sure don't believe it."

Bret's voice came softly. "You said that Cole seemed worried about some business stuff. Do you have any idea what it was?"

Donna's shrewd eyes moved to Bret. I could tell she was weighing the question, considering her options, trying to decide what to do. In the end, with an almost audible click, she made a choice.

"Is this off the record?"

Bret's shoulder twitched. "Donna, I'm off duty. I'm not investigating this when I'm on duty. John Green is. He'd have my butt if he thought I'd questioned you."

Donna sighed. "I'll tell you what I've been thinking about. Maybe it will help Lonny. But I don't want," here she paused, "to do something that will make Cole look bad. He would have hated that."

Bret said nothing.

Eventually Donna went on. "I don't really know exactly what was worrying Cole. He said it was something to do with business. He'd talked about us getting married; he said it was time to make some changes. All this was just in the last month.

"I've been thinking about it a lot, since he was killed. I can't help but wonder if there might be some connection. And the only thing that comes to mind is that file cabinet."

I saw Bret's eyes narrow. "File cabinet?" he said. "At his house?"

"Not here," Donna said. "There was a black file cabinet in his house on the coast. Every time we went over there, he always had paperwork he'd put there. Sometimes he'd sit down at his desk and go through some of the files from that cabinet. I keep thinking that he'd asked me if I'd go with him to the coast next week." She blinked. "It would have been this week. And I wonder if he wanted to get something from that cabinet. Or if the files had something to do with the business problems he mentioned. He was always kind of secretive about that cabinet."

"Didn't he keep records on a computer?" Bret asked.

"Not Cole." Donna smiled sadly. "He did most things the old-fashioned way."

"Where was his house on the coast?" Bret asked.

"Near a little town called Corralitos. The house was at the very end of a road called Richardson Ridge. Cole told me that his dad, Ron, was raised on the family ranch right there. The Richardson Ranch, it was called. The road was named after it. His dad sold the ranch off, but kept a small piece where the old family home was. Cole built a house on that piece."

I was taking this in with my mouth half-open. "But Richardson Ridge is only a few miles from my place," I said. "I've ridden to the end of that road."

Donna met my eyes. "Cole and I rode through those hills all the time," she said.

"Cole kept horses there?" I asked.

"Two," she said. "Cole liked to ride. We always went on rides when we were over at the coast. There was a trail that took us to a high spot where we could see the whole Monterey Bay. It was beautiful."

"The Lookout," I said, half to myself, half to her. "I ride there all the time. So is Cole's house one of the group of houses at the end of Richardson Ridge?"

"No." Donna shook her head. "That's a subdivision built on the land Cole's dad sold. Cole's house was a little further, on top of a hill, above the pond. You have to go up a gravel driveway to get there."

"I know that pond. I know where the driveway is. I always wondered what was up there. How did Cole keep horses there when he wasn't around to take care of them?"

"He had a caretaker," Donna said. "José, his name was. His wife was Elena. José took care of the horses and the yard and Elena kept the house clean."

"So they live there?" Bret asked.

"No. Cole didn't want them living there. They live in a trailer park a few miles away. They came morning and evening. When we were there Elena brought us groceries and did the laundry. José fed the horses. He'd had horses in Mexico. He knew about them. He'd have the horseshoer out when it was time, and the vet if it was needed."

Donna gave a sad smile. "They're nice people. And they took great care of the place. Even if we'd been gone for a month, it was always airy and clean, as if we'd been there yesterday. Elena would come every day while we were gone and open the windows and dust, and then close it up tight again every night. She kept it beautifully. And the horses were always slick and healthy, ready to ride."

"Sounds nice," I said.

"It was. And except for an hour in the morning and evening, when they came to take care of things, we had the place to ourselves. That was why Cole didn't want anyone living there. He liked to feel it was our place, when we were there. Other people living on it would have ruined it for him."

"I can understand that," I said. And I could. Suddenly I was

curious about the dead Cole. But there didn't seem to be any polite way to ask Donna about him.

For her part, Donna's face tightened up and she looked away. "I wonder if José and Elena even know that Cole's dead," she said, mostly to herself. "And I have no way to reach them."

"Could you call them when they were at the house?" I offered.

"No." She shook her head. "There's no land line there. Cole and I used our cell phones when we were at his house. Cole had a number for José and Elena at their trailer, but I have no idea where to find it. Cole was a private person," she said and blinked and turned away.

She began bridling her young sorrel horse, her back to us. Bret took the hint.

"We'll get going, Donna," he said. "Hang in there."

"I'm sorry for your loss," I said. I'd said this to her before, I knew. I just didn't know what else to say.

Donna smiled faintly and slipped the snaffle bit into the colt's mouth.

I followed Bret back out to the Jeep.

"What was Cole like?" I asked him, as we jolted from Donna's driveway back onto the dirt road.

Bret's shoulder gave its characteristic twitch. "He was a good talker," he said. "Most people seemed to like him. He had charm, I guess you'd say."

"What did he look like?"

Bret took a minute to answer this. "Cole was a good-looking man. Medium height, dark hair with just a little gray, light blue eyes, like Blake's. He was a lot more animated than Blake. More of a people person."

"And Lorene?"

"She was quiet. Looked a lot like her brothers. Dark hair, blue eyes. She was well liked around here."

I sighed. "I feel like I'm getting to know them in this weird way. In retrospect."

"I know what you mean."

Bret and I bounced down the road in silence, each lost in our own thoughts.

"I wish I could get a look in that black file cabinet in Cole's house on the coast," Bret said at last.

"Do you think the answer to these murders is there?" I asked him.

"Maybe. Or at least some information that would point us in the right direction."

"Away from Lonny, you mean?"

"Yeah." For once Bret sounded serious.

Lonny's gate was ahead. As I opened it, I could see the five pasture horses shaded up under a big oak tree on a grassy flat. Gunner's white blaze was easy to pick out; his tail switched lazily. It all looked idyllic, a swath of sunlight flickering across brilliant spring-green grass, the rounded olive-drab dome of the oak casting a cool blue shade over the red backs of the horses. I felt for a second as if I were stepping into an Impressionist landscape painting, an unreal, unchanging portrait of peace.

This bucolic image was oddly dissonant with the dark undercurrent of the murders, and I shook my head as I climbed back in the Jeep with Bret.

"I hope things get better," was all I could find to say.

But they didn't.

That night Kate's house burned to the ground.

Chapter 14

LONNY GAVE me the news in the morning, motioning me out to the corrals, while Blue fed Mac breakfast in the camper.

"They were both inside, Gail. Kate and her daughter."

"Oh my God." I felt as if someone had punched me, hard, right in the solar plexus. I had trouble catching my breath. "That little girl? Oh my God. I heard the sirens. I just didn't imagine."

"I saw the light from the fire around midnight and called 911 as I ran up there. But it was too late. The whole place was engulfed," Lonny said.

"Oh no."

"It was just an old shack of a house. Ancient wiring. God." Lonny's face looked as close to anguished as I could imagine that rugged, cheerful countenance looking. Apparently Kate's tragedy had touched him more than all his previous misfortunes.

"Jeez, Lonny," I said. "I'm so sorry."

Words seemed inadequate. I put one hand on his shoulder. "This is all being pretty hard on you. First Lorene, then being accused of murder, and now this."

Lonny shook his head vehemently. "It's that little girl, Gail. I can't stand to think about it." He shook his head again and abruptly got back in his truck.

Watching his strained face as he turned away, I felt the

clenched fist in my gut twist tighter. I knew Lonny. Never articulate at the best of times, he held emotions, especially painful emotions, firmly inside, keeping them to himself. Wounded as he was, this additional injury was just too much. Lonny was seeking a solitary, private space to hole up and lick his wounds. I doubted that we would see him again today.

I stared at the disappearing shape of Lonny's truck. Blinking for a second, I tried to take in the enormity of this new tragedy. I could hardly bear to think about it either. And now I was going to have to tell Blue and Mac. There was no use hiding it or postponing it. Mac was bound to hear some adult mention the fire. I had to find a way to tell him.

I did my best. I made the story simple, tried not to go into detail. Told Mac and Blue that Kate's house had burned down and Kate and her daughter were killed. That we were all very sad about it.

But Mac was not to be pacified with such a brief story. He had questions.

"That little girl died, Mama?" he demanded. "She burned up in the fire? And her mama, too?"

"Yes," I admitted, too stunned myself to find anything more to say.

"But she was just a little girl," Mac said. "Most things die when they're old."

"That's true," I agreed.

"She was about the same as me." Mac was clearly studying this and finding the parallels, damn it.

"If our camper burned up, could you save me?" he asked.

"Yes, I could. I would. Because I love you so much I would be strong and quick and clever. I would save us all." I shot a glance at Blue when I said this, aware that he was being markedly silent.

Blue raised an eyebrow at me and I shrugged one shoulder back. Sure, I knew the reality, but what could I say? A little boy needs to believe his mama can keep him safe.

Mac was not to be deterred. "But that little girl's mama probably loved her, and they both died in the fire. Maybe that would happen to us." Mac's big blue-gray-green eyes stared into mine. "Mama, I'm scared to die."

I sighed. "Baby, we're all a little scared to die. It's a big change."

"What happens when we die?"

"No one really knows for sure. I believe our spirits will go on. They leave our bodies and fly free."

"But you don't know?"

"Sweetheart, no one knows."

"Some day I'll die."

"Yes, that's right. But it will probably be a long time from now, when you're very old."

"But if I get old, then you'll die," Mac pointed out, with inescapable logic.

"That's true," I admitted.

"I'll be so sad when you die." Mac's long-lashed eyes were full of unshed tears. "I'll miss you so much. And when I get old, I'll die. I'm afraid to die."

I put my arms out and Mac snuggled into them, burying his face in my body. I wondered what the hell to say. Mac was asking the most fundamental question of human existence, and like every other human that ever lived, I didn't know the answer. I could only produce my own beliefs.

"I will always love you," I murmured to Mac, tears filling my own eyes. "Our spirits will still love each other when we die. When your time comes to die my spirit will walk with your spirit, hand in hand. And all your animals will come to be with you, Roey and Baxter and Toby. Toby will carry you on his back and we will all go together to the new place."

"Do spirits have hands?" Mac demanded, somewhat muffled by my shirt.

"Well…" I began.

"Then how can they hold hands?"

"I don't know," I admitted. "I just know that I love you and I always will. I believe we are part of the Love that created this world, that people call God, and that you and I, when we die, will be part of that love and you will be with it and with me. We will still know and love each other, maybe in a different way than we do in these bodies."

"I don't want to die," Mac said from my arms. "I want to stay in my body forever."

"I know," I said. "Most people feel that way. Death is a big change. Everybody's scared of it."

Blue smiled gently at the two of us. "Birth is a big change, too. Once you swam inside Mama's belly like a fish. And then you had to squeeze out and take your first breath of air and become a living human. Probably that little fish that you were, that we call a fetus, was scared to be born. It was a big change. But now that you're alive, it's not so bad."

"No," Mac agreed. And looked at me. "Will death be like that?"

"I think so. A big change and then we begin a new life."

"Do we get reborn as someone else?"

"Maybe," I said. I was getting to the end of my resources. I wasn't sure how many times I could say, "I don't know." Another mother might have told her child that we'd all live happily ever after in heaven, but I had to speak the truth as I understood it. I owed it to Mac. And the truth was, I didn't know. Neither did any one else, particularly the ones who were sure that they did. But there was no way to explain this to a little boy.

"If we do, then I want to have another life with you as my mama." And Mac smiled.

"I want that, too," I agreed.

"And maybe Toby can be my pony again. I miss Toby."

"Maybe he can," I said.

And suddenly Mac was skipping back and forth under the

oak trees, clearly imagining another life in which Toby was returned to him, along with, judging by snatches of his monologue, all the toys he'd ever wanted. At least he was smiling again.

I turned to Blue. "It's horrendous," I said quietly. "No one seems to know what caused it, or at least Lonny didn't seem to know. Maybe Bret will come tell us. I know one thing. I'm not going near the place."

"I agree," said Blue. "It's hard enough on Mac as it is. I wouldn't want him to see the house."

The two of us watched our sweet, ethereal little boy skip back and forth in the liveoak grove, making up stories in his mind. I knew we were both thinking the same thing. How much we loved Mac, and how unbearable it would be if we lost him. I thought of this other mother, who no doubt had loved her daughter, too, and perhaps died trying to save her. To no avail. And silent tears ran down my face.

Chapter 15

BRET SHOWED up that evening, just as we sat down around the campfire, margaritas in hand. Freckles barely woofed; she was getting accustomed to Lonny and Bret, and their arrivals and departures. Mac was up on the bed of the camper, reading a book, and peered out the window but didn't join us.

Blue offered Bret a margarita.

"Thanks," Bret said. "I'm off." His dirt-smudged face looked lined and weary. "It's been a long day. I could use a drink."

"Was it arson?" I asked, voicing the thought that had been on my mind.

Bret took a swallow of margarita before he spoke. "Fire captain says it's clear there was accelerant around the outside of the house."

"So it was set on purpose?"

"Yep. It's a double homicide."

"Was it intended to kill them?" I shivered.

"We don't know yet," Bret said. "But I think so. And whether the guy intended to kill them or not, when people die in an arson fire it becomes a homicide."

"Why do you think it was an intentional murder?" Blue asked in his quiet way.

Bret met his eyes. "I've been doing a little investigating," he said. "On my own. I'd like this to stay between the three of us."

"All right," Blue said.

"Okay," I agreed.

"You remember that I told you that Kate was a well-known blogger?" Bret began.

"Yeah," I said.

"She had this blog about rescuing horses that were headed for slaughter, just like she rescued Sunny."

I nodded.

"This morning I checked her last blog post, that she wrote yesterday, and read through all two hundred and fifty comments. At one point she mentioned that she'd been at the auction the night of the murders, looking at the horses in the pens. Just like she told you. And then she said she saw someone. Just a glimpse. As the person went into the office. She only saw the back. She wasn't really sure who it was. She wondered what to do."

"All this was in her post?"

"No. It was way down in the comments. More than one hundred comments down. Apparently there were people who wrote to her all the time. Sort of internet pen pals. One of them mentioned they'd heard about the murders. Kate wrote blog posts about going to the Carson Valley auction all the time. This internet buddy of hers asked her if she'd bumped off the auctioneer. And Kate wrote back that no she hadn't, but she was worried about it. And then what I told you."

"Oh my God," I said.

"That's right," Bret agreed. "That night her house was set on fire."

"The fire," I began, searching for some elusive thought that was nudging me, asking to be heard. "The fire was set around midnight..." And then I remembered.

"The rider," I said breathlessly. "Bret, remember the rider? Do you think?"

"It's possible," Bret said, and I could tell that he'd thought of it. "But there are so many hoofprints in this pasture that it's impossible to tell if anyone rode through it last night."

"Of course. But what if the rider is the murderer?" I was babbling now, talking as fast as I could as the thoughts tumbled around. "What if he rode through here and set Kate's house on fire to silence her?"

"Because he read her blog and knew she'd seen him at the saleyard?" Blue asked.

"He may already have realized that Kate was there at the auction," Bret pointed out. "She saw him; he might have seen her."

"Right," I said. "But if he was the rider, why didn't he burn her house down the night I saw him? Before she had a chance to say anything to anyone?"

"Maybe he wasn't sure if she'd seen him," Bret said. "He only found out when he read her blog yesterday."

"And maybe because Lonny was still in jail," Blue said quietly, a question in his voice.

"Oh," I said, the implications of this dawning on me. "Is Lonny suspected of setting this fire?" I demanded of Bret.

"No. Not yet," he said.

"Is that detective going to go there eventually?"

"I don't know," Bret said. "As far as I can tell, John Green doesn't know that Kate saw the suspect in the auction murder. He doesn't know there might be a connection between the two crimes."

"Are you going to tell him?"

Bret stared at the fire for a long time, swirling his drink. "I don't know," he said at last. "I might have to. But not yet."

"If you do tell him, this guy's gonna try and pin the arson on Lonny. He'll be sure Kate saw Lonny at the saleyard."

"Maybe," Bret agreed.

"She didn't. She was absolutely sure that Lonny was innocent. Whoever she saw, it wasn't Lonny." I knew my voice was getting shrill.

"I know. But Kate's dead, and can't explain that." Bret's eyes were on the fire.

"We can't let it happen. It would kill Lonny if he were accused of this. He's just sinking under the weight of everything already, I can tell."

Bret nodded. "I'm with you, Gail. I think Lonny's innocent. I don't want to cause him more grief. I don't know what I'm gonna do here."

We were all silent, the various ramifications sinking in. I could see Mac through the camper window, quietly reading his book on the bed.

I stood up. "I need to start making dinner," I told Bret. "Want to stay?"

"No. I'd better get home. It's an hour drive." Bret stood up, too. "I've got a lot to think about."

We said our good-byes and watched his car drive away. I turned to Blue.

"You know," I said, "I think it's time we went home. This is all getting too creepy. The idea that the killer is riding through this pasture at night scares the crap out of me."

"We don't know that," Blue pointed out.

"Right," I said. "I'm still creeped out. And Lonny might need a break from having company, anyway. I notice he hasn't come around at all today. I think he needs some space and time to lick his wounds, so to speak. Blue, I just want to go home." I didn't bother to add my other reason for wanting to go back to the coast, feeling sure that Blue would not approve of it.

"Fine," Blue said, agreeably enough. "It's just a three-hour drive. We can come back if we're needed. We'll take off tomorrow. Still want to leave Gunner here and take Sunny home?"

"Yes," I said. "I think so. I'll talk to Lonny about it in the morning."

I headed into the camper to make hamburgers and tell Mac we'd be going home the next day. He seemed quietly willing, from

which I deduced that the deaths of Kate and her daughter were still upsetting him, perhaps more than we were aware.

That night at bedtime he crawled into my arms with a soft "Cuddle me, Mama."

"Of course," I said, holding him close. "I love you."

"I love you, too."

Mac snuggled into my body, his back curving into me, not fully awake, not yet asleep. In this quiet moment we were close, connected, warm, alive, the little sparks of our spirits securely housed in our cozy, cuddled bodies, mama and child. What comfort there was in this sweet physical content.

I understood the depth of Mac's fear of the great unknown. Death was such a mystery. I might say that our spirits would still love each other, but what did I know? Nothing but that we snuggled right now in the warmth of our two living bodies, in the gentle rise and fall of our breath. When the breath was gone and the body cold and empty, what then?

This was what Mac wanted to know, what we all wanted to know. I could hand him my belief that love would be there, but it was just my belief. A feeble, tattered rag to flutter, when he wanted and needed a sturdy staff of truth to help him cross that dark river. And I had no such thing to give him. Neither did anyone else. No living human had any true knowledge of death. All we had were our various beliefs.

Laying my cheek against his hair, I whispered, "I love you, Mac."

It was all I had.

"I love you, too, Mama," he murmured, more than half asleep.

I smelled the sweet smell of his breath. Our bodies breathed together. My hand found Blue's hand, and as if he could guess my thoughts, together we wrapped our linked arms around our little boy.

Chapter 16

HOME. I hadn't known how much I'd missed it until I realized how happy I was to be there. Blue had barely parked the truck before we were scrambling out, dog, kid, and all, greeting the cats and oohing and aahing (in my case) over rosebushes newly burst into bloom.

Mac was busy petting Shadow, our youngest cat, a small black "tuxedo" female who had been given to us by our neighbors shortly after Baxter had died. Rowan, the thirteen-year-old neighbor girl, had found Shadow as an abandoned two-week-old kitten and managed to raise her. When Mac first held her she was still a scrawny little eight-week-old mite of a thing, and it constantly surprised me to see the sleek and graceful cat she'd grown into. Unlike all our other cats, who were ex-ferals, Shadow was very, very tame. She rubbed back and forth on Mac's legs, accepting his strokes and meowing constantly.

"She's talking to me," Mac said. "She's saying, 'Where were you? Why did you leave me?'"

"That's right," I agreed. "I think she missed sleeping on the bed. But Rowan took care of her."

Rowan had agreed to feed the cats and chickens while we were gone and keep an eye on things for me.

"Where's Tiger?" Mac demanded.

"I'm not sure," I said. "But he'll turn up."

I walked to the rear of the trailer to help Blue unload the horses. First reliable Henry, then Plumber, and finally my new acquisition. As I turned Sunny loose in his corral, I had to smile. "That bright gold color is just so cheering," I told Blue. "He's like a little patch of sunshine."

"He's aptly named," Blue said, and smiled back at me.

Sunny, as usual, appeared quite unperturbed by his new circumstances. He looked around his corral calmly, snuffled the ground, and had a roll in a patch of loose sand. He then sniffed Henry's nose through the corral fence and ambled over to take a drink of water from the trough, seeming right at home.

A squawk from the chicken coop made us all turn in that direction. The seven banties in the run fluffed their feathers and clucked, pacing back and forth, anxious to be let out. We'd left them locked up while we were gone, to make it easier for Rowan to care for them. We'd lost so many lately to bobcats, coyotes, hawks, raccoons, owls…etc, that we carefully shut the chickens in every night and whenever we planned to be gone. Last month a bobcat had taken Gange, our beautiful head rooster, and we were still gun-shy.

"Shall we let them out?" Blue asked. "They've been cooped up a long time, and I plan to work in the vegetable garden this afternoon. I'll keep an eye on them."

"Okay," I said, and Mac hurried to open the gate to the run.

The chickens burst out with much squawking and excitement, led by Rob Roy, a brilliant red rooster who had become the leader after Gange's demise. Three hens and three younger roosters followed him, our current flock. I was hoping one of the hens would start to set soon. We needed a few replacement chickens.

Mac and Blue and I watched the banties peck around the barnyard and dust themselves in the horse corral. I could feel a smile forming on my face. I was home.

Home. I looked up the hill to where my little house sat, framed by brush and liveoaks, backed by the ridgeline. Shingled all over with untreated cedar shakes that had weathered to a rusty silver, the house was tiny, only six-hundred-fifty square feet, with a green tin roof, a big front porch, and lots of windows. Seeing it now, after being gone, I was struck forcibly by its otherworldly quality. A little fairy house in the woods.

My little fairy house. In another moment Blue, Mac, Freckles, and I were marching up the hill, Shadow trotting at our heels, still complaining. Halfway up the drive Tiger, our biggest cat, a huge tabby ex-feral, ex-tomcat, emerged from the brush, adding his voice to the chorus of meows.

"Tiger missed us, too," Mac said.

"Yep," I agreed. During his time with us Tiger had gone from completely and untouchably wild to tame enough to sleep on the bed, along with Freckles and Shadow. No doubt he missed his comforts.

"He'll be happy tonight," I said.

Mac grinned and skipped up the hill with the cats and dog behind him, joy in every animated gesture.

Blue opened the door and we all trooped down the short hall. I smelled the sweet scent of the rough-sawn knotty pine wood that paneled the interior of the house. Everything looked friendly and familiar and yet new. We'd only been gone a week, but it felt like a month.

The main room of the house, twenty by twenty feet, with a high open-beam ceiling, seemed to welcome us. Sunshine streamed through the uncurtained windows onto the primitive wool rug on the mahogany hardwood floor. The woodstove sat quiet on the gray stone hearth in one corner, as did the computer on its sleek black desk in another. The terra-cotta tile counter that ran across the far wall, broken by stainless steel sink, stove, and refrigerator, was neat and clean. All just as I'd left it. Waiting for us to come home.

I sighed with pleasure. Mac ran into the bedroom and began jumping on the bed. The cats and dog seethed around underfoot, greeting each other, rolling on the rug. Blue was carrying our bags into the hall. We were home.

Two hours later, we'd had lunch, unpacked, and settled in. It was early afternoon and Blue was weeding his beloved vegetable garden. Mac and I had wandered down to the barnyard. Mac was in the swing that hung from the oak tree. I sat in one of the two chairs by the barn and watched Sunny doze in a patch of shade. Cinders, our shyest cat, slept on the roof of the pasture shed, his favorite roost. It looked as though all three of our current felines had survived our absence.

"Can we go for a ride, Mama?" Mac asked.

"Good idea." I was eager to see the familiar trails on the ridge across the road.

Glancing up, I spotted the landmark tree silhouetted on the skyline. An ancient skeleton of a huge Monterey pine, the landmark tree was visible from our porch and dominated the network of trails that criss-crossed the opposite ridge. It often reminded me of a totem, a symbol of the spirit of these hills. I was ready to ride by it again. And there was something else. I had an experiment to try.

"I'll ask Papa if he wants to go," I told Mac.

But Blue was determined to get the garden weeded. I saddled Sunny and Henry and gave Plumber a flake of hay to keep him quiet while we were gone. And Mac and I set off down our driveway and out our front gate, with Henry on the lead rope behind Sunny.

Mac was an adept rider, and Henry was absolutely reliable. I had never once "ponied" the two of them during the time we'd spent riding in Lonny's pasture. But to reach the trails on the ridge we had to cross a very busy road, upon which the cars zipped along at fifty miles an hour. Not to mention the busses,

trucks, motorcycles, and bicycles. In short, crossing the road was hazardous, and I always kept Mac on the pony rope while we did it.

Sunny marched steadily down the short cul-de-sac that led past my neighbors' places. Ahead of us the cars whizzed by. I sincerely hoped that Sunny would remain his usual unflappable self when dealing with traffic.

We reached the shoulder of the road and stood, waiting for an opportunity to cross. I had Mac keep Henry behind me, well out of harm's way. Sunny and I, however, had to stand virtually in the bike lane in order to get a clear view of oncoming traffic. I took a hasty step backward as I saw a belching school bus approaching, followed closely by a road bike going almost the same speed as the bus. Sunny never flinched.

Despite this, I was tense as a fiddlestring. I hated crossing this road. It brought my heart to my throat every time—I recognized the very real danger it represented. Horses and traffic are a bad mix. But, to my relief, Sunny continued to stand like a rock, completely unfazed by the logging truck whistling by not ten feet from his nose. Henry, as always, stood calmly, waiting for the signal to cross. I often thought Henry ought to be canonized.

After many long minutes a gap in the traffic occurred. I could see no one coming in either direction. I clucked to Sunny and bumped his sides with my heels.

"Kick Henry up to a trot," I told Mac.

The two horses trotted across the road, achieving the opposite shoulder before anything bore down on us. I always crossed at the trot, having discovered that if I walked I might find myself in the path of oncoming traffic by the time I crossed the center line.

"Good job," I said to Mac, once we were off the road, and I unclipped the lead rope from Henry's halter.

We took the trail that led into a tangled grove of liveoaks. The twisting, charcoal-marked gray trunks twined around us in sinu-

ous shapes, graceful as the limbs of dancers. Loose brown and tan duff underfoot was dappled in the lively, mutable patterns of the shade that flickers through an oak tree. Olive green leaves rustled softly overhead. The shift from loud, angry traffic to quiet peace was startling.

The two horses paced steadily along in a rhythmic, quiet walk. I looked back to see Mac's head turning from side to side, taking in his surroundings. The narrow ribbon of the trail wound through the trees ahead of me. We were in the woods.

Chapter 17

I COULD SEE light up ahead, and then we were in the brilliance of a small meadow, already dusty, the grass turning from silver-green to gold in the way of coastal California spring. We paced down the path, Henry following Sunny. Then up the hill into a eucalyptus grove, shadows barring and dappling the trail, leaves and sticks crunching underfoot, the tall, rustling blue gums waving their crowns high above, creaking and squeaking in the faint breeze. Hushed in the gentle gloom, we plod along, turning a corner to scramble up a steep bank, picking our way between brambles and briars. I duck for a very solid, low, overhanging limb, looking back to be sure that Mac ducks, too.

"Watch out for the head-bonker tree," I call, and see Mac smile and duck low over Henry's neck.

Along a sidehill we go, stepping slowly through the small ravines, shaded by oaks, pines, and eucalyptus, moving through the soft dappled green shade. I bend Sunny carefully to skirt a crooked tree trunk that leans into the narrow trail. Finally we crest the ridge and drop over into the bright sunlight of a big meadow. The trail runs through the middle of the golden-yellow dry grass, the exact color of Sunny's shiny neck. A yellow horse in a yellow field.

I look around as I ride. Scrubby oaks dot the meadow, mixed with the occasional ceanothus bush, covered in soft violet-blue bloom. I can smell the honey-like scent as we ride by and hear the bees buzzing on the blossoms. I see a quiet, dark shape in a shadow; a resting doe, lying under a liveoak tree. Pointing in her direction with one hand, I whisper to Mac, "Deer."

Mac looks and nods. The doe sees us, but remains quiet, hoping we'll go by and leave her in peace. Sunny marches steadily on, Mac and Henry right behind. The air is warm here and smells sweet. Rustles in the brush make me turn my head; Mac looks, too. That flickering motion is birds, I know. I can't see exactly what sort. Sunny pricks his ears in that direction.

The trail lies straight ahead of us, a long, flat, sandy stretch, passing through mingled grassland and scrub, running slightly uphill.

"Can we lope, Mama?" Mac asks.

"Sure," I say and, clucking, I boot Sunny up into his heavy, rolling lope, which reminds me of a small draft horse.

Looking over my shoulder, I see Mac loping after me on Henry, a huge smile on his face. Henry's eye is calm, his white-striped face steady as he rocks along in a relaxed lope, his copper-colored mane flaring in the air.

"This is great," Mac yells at me. "I want to lope forever!"

I grin back at Mac, and relax into the rhythm of the gait. The wind lifts the hair off my face and blows Sunny's mane back across my hand. The horses snort; the saddles squeak. I glance back again to see Mac's smiling face as he canters along.

"This is great!" he tells me again.

I can see the hill coming up where we will slow, but in this moment we are perfect, free and happy in the wind of our passing, moving through the streaking landscape.

"Thank you," I whisper. To the horses, the land, the trees, the whole green world.

Now the trail curves into the "cold valley," a steep, shady

ravine on a north slope. We fall back to a walk. The temperature drops ten degrees, and I shiver. We can hear frogs peeping in a small mud puddle of a pond, off to the right. Willows line the trail and interweave overhead, turning our passage into a green tunnel.

The trail leaves the bottom of the gully and starts up the hillside. We are passing through a redwood grove, ascending through dark red-brown pillars in deep shade, the blue-green needles forming a dense canopy overhead. I smell the rich, loamy smell of the redwood duff underfoot.

The trail grows steeper. Sunny is digging hard as he marches up the hill; I can feel him working; can see the sweat on his neck. He breaks into a trot, Henry following suit, the two horses huffing a little and using their momentum to defeat the climb.

The trail levels out in a tangle of pale pink wild currant blooms and the white flowers of blackberry vines; for a moment we are surrounded by blossoms and dappled light. Bright blue houndstongue, a giant forget-me-not, lines the trail. I look up and see the antler-like crown of the landmark tree high overhead as we ride past it. We are deep in the green world now.

Looking down, I see the hoofprints of deer and horses; that's it. Not a human footprint to be seen. These wild trails aren't used much, though I have occasionally seen riders from a local boarding stable.

On we go, up and up, the horses working hard, until we reach another level spot. The trail forks here; the right-hand turn leads back down the ridge toward home. The horses are puffing and sweating, and we stop for a while to let them rest and breathe. We call this spot the "three-way trail crossing." I stare at the huge oak tree, multi-trunked and branching, that dominates the flat. Bright green moss coats its silver-gray curving lines; warm afternoon sunlight slants through the branches in patches and flashes of gold on green. The horses puff, their flanks moving in and out.

Mac smiles at me. "I'm glad Henry is doing the work and not me. Or else I'd be tired now."

"Yeah, me, too," I say.

When Sunny and Henry have aired up and aren't puffing any more, we head down the trail that goes to the left, farther into the woods. The next hill is steep and the horses grunt and scramble a little as they trudge upward.

"Not too far now," I say out loud, and Mac smiles. He knows where we're headed.

Upward, ever upward, between oaks and redwoods and madrones, with big vistas opening up on all sides. We can see the distant slopes and the faraway blue crest of the coastal mountains.

Now we're on the last steep climb, passing through a group of ancient madrones, their rust red trunks curving in graceful arabesques toward the sky, their big, sparse, shiny green leaves reflecting the sun. We are high on the ridgeline now; through the trees I see hills rolling all around and below us, a tossed and

tumbled carpet of misty blue velvet. Ahead of us is openness and light.

At last we top the hill and emerge between the twisting shapes of the madrones into a small meadow at the crest of the ridge. The short grass in this clearing is bleached gold, covered with the deep-blue violet flowers of sky lupine, so aptly named. The trail leads through ground as blue as the sky. The air has a spicy scent. The blue is beneath us, above us, and before us. We ride across the meadow to a steep bluff that faces out to sea.

"We're here," I say to Mac, and he smiles again.

We're at the Lookout.

Chapter 18

THE LOOKOUT sits high in the hills, with a big view out to the west. We can see Monterey Bay in its blue entirety; we can see Pigeon Point to the north and Point Lobos to the south. Every promontory sharp and clear this bright spring day. We look out to the west where the sky meets the curving horizon of sea and know that if we could look far enough we would see Japan. We are on the very edge of our continent.

We sit there and stare, Mac and I, lost in this view of the Pacific rim, the rolling hills of Santa Cruz County, the open blue sky, the flying breeze. The horses puff, content to rest and catch their wind. We are all silent. There is nothing to say, nothing to want.

"Look, Mama," Mac says at last. "There's the four flagpoles."

"Yes," I say, seeing the tall white spikes in the middle distance.

Months ago Mac had pointed out these flagpoles to me as we drove along the freeway in Aptos. "Those are the four poles we see from the Lookout," he said. And they were.

And here we were. For just this moment, in a perfect world. I stared down at the sunlight gleaming on Sunny's silvery-gold neck and glanced at Mac's happy, open face. I let my eyes drift around the wide spaces that surrounded us, a tapestry of hills and sea and sky.

For a second my heart clutched. I want to hold us in this

moment forever. Free and happy and whole, on our horses, on the roof of our world. But moments can't be held.

Gradually Sunny's breathing returned to normal. Mac shifted in his saddle. "Where shall we ride to?" he asked.

I got off and tightened both horses' cinches. Climbing back on, I said, "I'd like to ride to Tucker Pond."

"Can we go through Moon Valley and the old orchard, and then back by the swingset trail?"

"Well, that's going the long way, but okay, if you want to."

Mac was instantly eager, and we set off down the trail that dropped steeply from the Lookout to Moon Valley. I rode quietly, my mind on what Donna Wells had told me. Cole Richardson's house was at the end of Richardson Ridge. I knew exactly where Richardson Ridge ended—at the old orchard. I'd ridden to that spot before, many times. From Donna's description, I thought I knew where Cole's house was. Right above Tucker Pond. I thought we could ride there. I had a notion to see Cole's house. Where the mysterious black file cabinet resided.

Down the ridge we went, through another eucalyptus grove, following the trail.

"Look," Mac said. "There's our house."

We both looked out to the north. From the ridgeline we were on, we could see the tiny, green-roofed, triangular shape of our own house, perched near the top of the opposite ridge.

"Papa's in the vegetable garden," Mac said wistfully, staring in that direction.

We both smiled at the thought. I wondered why I stared longingly from my porch at the landmark tree on this ridge and equally longingly from here back at my own front porch. The much-loved places seemed most dear when one was removed from them. Perhaps it was a basic human thread. The landmark tree was below me now. I could feel the same wistfulness in my heart that I heard in Mac's voice. Whatever it was, it was an emotion I recognized.

We rode on until we dropped down into Moon Valley and followed the creek through scattered groves of willows that changed to oaks as we headed back up into the hills. The trail led on through shadow and sunshine, underneath a huge old cedar tree, through tangled vines and green grass and big clumps of wild iris. I admired the varying shades of each new stand of flowers, ranging from almost pure white through bright violet to deep purple. Mac pointed out a swath of pale blue forget-me-nots lit up with sunlight, backed by the velvet brown darkness of a big redwood grove.

Our voices hushed as the trail led into the grove. No matter how many times I rode this way I never got used to it. The redwoods stood on the valley floor, their trunks huge pillars reaching up into the green gloom overhead. The shade beneath them was absolute. The eerie stillness was uncanny. As if one had suddenly stepped into an empty cathedral. The horses paced on, tiny travelers amongst the giants. I was reminded of the roots of the word "awful."

Once out of the big redwood grove, the trail led up the valley, though small meadows and tunnels of green brush, under the arching madrones and between the twisting liveoaks. On and on we rode, passing a trail fork that led to the right. I knew that trail. Many years ago I'd met a cougar there, on a solo ride with Plumber. I shivered and glanced reflexively over my shoulder. But no predator awaited. Just sunshine and my child's happy face.

Still, we were in the land of the wild things now, which I knew very well. Cougars did roam these hills, along with coyotes and bobcats. The latter two were no threat to us, but cougars had been known to jump horses. Ranches very close to where we were had pastured horses that bore the scars of the big cats. I believed that as two mounted horsemen we were in no danger, but that quick glance over my shoulder happened more and more often, the further we rode into the hills.

The trail twined through another tangle of oaks. The light ahead told me that we were getting near the orchard.

Mac and I were both grinning as we emerged from the oaks into the sunshine and blowing grass of the meadow. Scattered and gnarled, a few ancient apple trees bore rose-tinted white flowers with that faint and indescribable scent of apple blossom, the essence of spring. Sun and breeze swirled around us. Like the Lookout, the old orchard had a big view out to the west, over Monterey Bay. A windy verge of meadow grass ended in a bluff that overhung the dark, winding, tree-filled corridor of Moon Valley below us, leading off into the distance towards the sea. Mac and I pulled the horses up.

"Look," said Mac, "that's where we were." And he pointed to the tall spires of the redwood grove in the middle of the valley.

"Yep," I said.

Turning my head, I looked to the east. There at the high edge of the meadow I could see the scattering of big houses that marked Richardson Ridge, an upscale subdivision. Donna had said that Cole's house was farther on, at the end of the gravel road. Well, I knew where the gravel road was.

Mac and I rode across the orchard until we struck the road, which led down the hill and through a sun-splashed grove of oaks. In another quarter mile or so we reached Tucker Pond. Fringed with reeds and screened by a clump of willows, it sat in a natural hollow in the hills, backed by a small redwood grove. Frogs peeped, redwing blackbirds shrilled. The water was an opaque mud brown, full of spring runoff. Mac and I turned curious eyes on the pond, as we always did. It, like the landmark tree and the Lookout, was one of the main features of our rides.

My eyes swung to the right, following the gravel road. On all previous rides we had turned left on the trail that continued past the pond to an abandoned swingset in the woods and thus to home. We called this the "swingset trail."

The gravel road ran up the hill to an unseen house. A house I now knew to be Cole Richardson's coastal residence. What had Donna said? The caretakers came for an hour in the morning

and evening. It was currently midafternoon. Unlikely that anyone would be around.

"Let's ride up the hill," I told Mac. "I want to see what's up there."

"Okay, Mama."

Sunny would have preferred to take the homeward direction, but obediently swerved to climb the graveled driveway, Henry behind him. We hadn't gone past a few bends in the road when we heard a neigh ahead of us.

"There're horses up here," Mac said.

Sunny and Henry pricked their ears. Another bend in the road showed a small corral and barn in a level space carved out of the hill. Two dark horses stood in the corral. Both wore halters. Both nickered at the sight of us.

I looked around apprehensively, but no dog barked, no human emerged from the barn. Donna had said that the caretaker fed the horses morning and evening.

"Come on," I said to Mac. "Let's see what this house looks like."

We rode on up the hill, leaving the horses behind. The road curved, the trees made a screen, but I had the sense that the house was there, above us, waiting. It was bothering me. I had no reason to think there would be a problem; the house ought to be empty. And I was only going for a ride in the woods, for heaven's sake. But I couldn't shake the gathering anxiety that seemed to emanate from this place.

I glanced back at Mac. His face was very still, and for the first time on this ride, he no longer looked animated and happy. Sunny and Henry had their ears straight forward, peering ahead. I could feel the tension in Sunny's body as we rounded the next curve in the road.

And there it was.

Chapter 19

COLE RICHARDSON'S house sat above us, broad and square and gray and implacable, surrounded by a virtual fortress of decking, sprawling over what seemed like several acres of the wild woods, which it dominated with ease. The whole place looked oddly gray, as if a cloud had passed over the sun; all the brightness that had filled the old orchard was gone. Despite the fact that the house was in the open it seemed dimmed and somehow darkened.

I stared. Mac stared. Sunny and Henry stared. The house looked absurdly out of place, a monstrous, giant, rectangular growth defiling the woods. Even though I knew these hills held many huge houses of this sort, the residences of rich men who affected a country lifestyle, I was still shocked when I saw the actual ten-thousand-square-foot examples. And this house was worse.

Why, I didn't know. Something in its silent, square, gray blankness had a brooding, heartless quality. Don't be fanciful, Gail, I chided myself. But I shivered, and glanced back at Mac.

My son's face remained still and somewhat tense, his eyes fixed on the house. He caught my glance and whispered, "Mama, let's go. I don't like it here."

I had to agree. I didn't like it here, either. I took another look, trying to figure out what it was that was bothering all of us. It wasn't obvious. Just another large, boring, generic mansion, this one gray, with a flat roof and lots of deck around it. No garden to speak of. A paved apron of drive, empty of vehicles, before a closed garage door. No one around, which I had expected. But the house didn't look empty or abandoned. Windows were open. I squinted. It even looked like one of the sliding glass doors was half open, with the screen pulled across. As if someone were there, inside, waiting.

No one's there, I reminded myself sharply. What is there is that black file cabinet. The one Bret believes holds the secret behind Cole's murder. That's what's there.

A finger of breeze brushed my face; sudden motion from a window made me jump. Sunny flinched. A white thing billowed from the window. Shit.

I stared. Sunny stared, both of us frozen in place. I took a deep breath. It's a curtain, Gail, for heaven's sake. A curtain blowing in the breeze. Not a big deal.

And suddenly I'd had enough.

"Let's go," I told Mac.

And we turned the horses and started back down the hill. Both the geldings jigged a little, unusual for Henry, and unlike Sunny, as far as I knew. I couldn't tell if it was eagerness to get home or distaste for the silent house behind them that was causing their agitation. I didn't really care. I felt the same way. I wanted out of here, away from Cole Richardson's house; I wanted to go home.

But home was still a long ways away. Mac and I rode our restless, prancing horses past the lonely barn in the woods. The two dark horses in the corrals nickered plaintively at us. The small barn had a stout hitching rail out front. It looked as though the tack room door was padlocked shut. Two lead ropes hung from a hook by the gate. We rode on. Finally we were at the bottom of

the hill. I turned right on the trail that led past Tucker Pond. In another moment we were in the woods, trooping through a long tunnel of green shrubbery.

"There's the old car," Mac said cheerfully.

We both looked to our left, where the rusting body of an ancient car lay abandoned in the brush. Not too far ahead were the remains of a house and barn that I assumed had housed the owner of the car. The ground beneath the oak trees was carpeted with the shiny green leaves and purple star-shaped flowers of vinca, run amok from that long-ago garden. No doubt an ecological disaster, but very pretty to ride through, all the same. It wasn't until we passed the old swingset, standing forlornly at the fork in the trail that led to home, that it hit me.

"The Richardson Ranch," I said out loud, as we took the right-hand fork.

"What, Mama?"

"Oh, nothing. I just wondered who lived in the old house and played on the swingset," I said.

But inwardly I thought I knew. Donna had said that Cole had kept the family homesite and built his house on that piece. Surely our familiar swingset and the house that went with it were the old Richardson home. This was where Cole's father had been raised. What was his name, Ron? Looking back over my shoulder at the swingset, solitary in its clearing in the woods, I could almost see the ghost of a little black-haired boy, swinging high amongst the oak trees. Quickly I put my eyes back on the trail ahead.

Too many ghosts. Ghosts in the big gray house on the hill. Ghosts in the crumbling old ruins in the woods. Ghosts everywhere.

Mac and I rode in silence. Up the hill, down the ridge, through the wide, windy meadow filled with rustling clumps of pampas grass, back to the trail we'd started out on. We stepped

quietly through the dark woods that grew on the sidehill. Everything was dimmer and shadier now as the sun was waning. Long bolts of golden light came shooting through gaps in the trees to light up the gloom.

Neither of us said a word as the horses picked their way across the ravines and wound between the twisted tree trunks. We ducked automatically for the overhanging limb, and leaned back as the geldings half slid down the steep bank. Our silence wasn't unusual; we were frequently quiet as we rode through the woods. This time, though, I sensed that we were both busy with our thoughts, rather than contemplating the green world. And those thoughts concerned that house behind us.

Cole Richardson's house. With ghost-like blowing curtains. With a file cabinet that might hold a secret that would save Lonny.

We were crossing the small meadow near the road now. I pulled Sunny up, and Mac stopped Henry. Clipping the lead rope back on Henry's halter, I led him through the oak grove to the shoulder of the road, and stood there, craning to see. In the late afternoon light the cars were harder to discern clearly. A gray car coming around the far bend looked all too much like a patch of pavement. I stared and stared, waiting patiently to be sure. There was no tolerance for mistakes. Mistakes here could be lethal.

When all was perfectly silent and still, I clucked to Sunny and bumped him with my heels. "Kick Henry up," I said to Mac. "Let's go home."

That night, after Mac was asleep, I told Blue about Cole Richardson's house on a hill.

"It was weird," I said. "I didn't like it. It gave me the creeps."

"Because you knew the owner had been murdered?"

"Maybe. But I don't think so. It was just the way it felt. Some vibe it had. Like a bad aura."

"Sounds pretty new-agey to me," Blue said.

"I know. But Mac and the horses could feel it, too, I swear. Nobody liked it there."

Blue shrugged. "Big, empty mansion way out in the woods? Sure. It's a little creepy. No reason why any of you would feel comfortable there. Don't make it more than it was. Are you trying to tell me it's haunted?" And Blue grinned.

I didn't smile back. Inescapably, my mind pictured that white curtain blowing out the window; the memory of a little boy on the abandoned swingset.

"Who knows?" I said, almost crossly. "I'm trying to tell you it creeped me out. It gave me a bad feeling. I'm trying to figure out what it was telling me." I compressed my lips on this statement. Perhaps I wasn't being entirely truthful, but close enough.

Blue looked at me patiently. "You've said often enough how much you hate these great big ugly new houses that are perched on half the hills around here. I don't like them myself. Why is this one any different? Other than you know the owner was murdered."

"I don't know," I said. "I have no explanation for how I felt. But I am curious. I think I'm gonna ride back there tomorrow, without Mac, see if I can make sense of it. Can you take him somewhere?" There, I'd said it.

"Sure," Blue said. "We'll have a father-son expedition. Maybe we'll go to the Boardwalk."

The Boardwalk was the local amusement park, a picturesque seaside carnival that dated from the early nineteen-hundreds and was much loved by Mac.

"That would be great," I said. "I've been wanting to take a solo ride on Sunny, anyway. See how he goes by himself. Spend a little time getting to know him. When I ride with Mac, most of my focus is on my kid." This part was true, anyway.

"No problem, Stormy." Blue pulled me closer to him on the

couch and kissed me. "You go take your horse for a ride and check out your haunted house. Mac and I will ride the roller coaster."

"That'll be a thrill," I murmured as I kissed Blue back.

"Not as big of a thrill as you're going to give me now." Blue smiled and tipped my head back. "Or so I hope."

I leaned back against the cushions. "Right," I said, as I un-buttoned his shirt. "Do you want to put your hands in the air and scream?"

Blue laughed.

Then we were both quiet.

Chapter 20

BRET CALLED the next afternoon, after Blue and Mac had left for the Boardwalk, just as I was headed down to the barn to saddle Sunny.

"John Green's looking for some evidence to pin the arson fire on Lonny," he said. "He hasn't found anything yet, but that's the direction he's headed. I sat down with him, told him my theories about Cole, told him about Kate and that she might have seen the suspect at the saleyard. Now he thinks she saw Lonny."

"But Kate was adamant," I said. "She was sure it wasn't Lonny. If there was any doubt in her mind—"

"I know," Bret interrupted. "I've only got a minute here. John Green doesn't care. Kate is dead and can't talk. Old John is looking for a simple, logical solution to this deal. If Lonny killed Cole and Lorene, maybe he killed Kate because she saw him. And dammit, I'm the one who told him that Kate saw the suspect."

"Shit," I said.

"I just thought you'd want to know," Bret said.

"Yeah," I said, "Bret, what about this house over here on the coast? I found it. Couldn't you drive over and have a look at that file cabinet? Maybe that would tell us something helpful."

"I wish I could. But I need to be there officially. If I just snuck

over there and broke in, the evidence would be tainted. We might not be able to use it. I've got to think of a way to interest John Green in the whole idea. I'll work on it. Got to go." And he hung up.

I stared at the silent phone and said, "Shit" one more time for good measure. Then I dialed Lonny's number.

Lonny answered on the first ring, which told me he was in the house. Not good.

"Hi," I said. "How are you doing?"

"I'm still here, I guess."

Lonny didn't sound like himself. The timbre of his voice was softer, the usual forceful energy missing. He sounded old and tired, almost hesitant.

"Hang in there," I said. "Do you want us to come back? We can. Any time."

"That's all right," Lonny said. "I'm not very good company right now."

"You don't need to be good company. Would it help if we were around?"

"No. Gail. I'm better off by myself."

I heard the heaviness in Lonny's slow voice and recognized that he truly just wanted to hole up. Which is what I would have felt like doing in his shoes. Talking to others, even friends, was more of a burden than a comfort.

"Hang in there," I said again. "Everyone knows you didn't do this." Except John Green the detective, apparently, I thought silently. And quite sincerely prayed that Lonny was never actually accused of burning Kate's house down.

"I meet with the lawyer again on Monday," Lonny said.

"Good. That's tomorrow," I reminded him. "I'm sure the lawyer will have some good ideas."

"I hope so." But Lonny's tone wasn't particularly hopeful. More like defeated.

"Hang in there," I said for the third time. Damn. I sounded like a broken record. I just couldn't think of anything else to say.

"I'll call you tomorrow. Take care of yourself" was all I could come up with.

Lonny and I talked for a minute more. He told me the horses were fine and Gunner was thriving. We said our good-byes. And I stared at the silent phone and said, "Shit," again.

Then I marched out the door and down to the barn, frustration seething through every inch of me. I felt a little better when I spotted Sunny dozing under an oak tree. I grabbed a halter and went to catch him.

"Come on, little guy," I said. "We're going for a ride."

———

Sunny plodded quietly down my driveway and out the front gate, seeming unperturbed by the lack of companions. Good. Very good.

Henry and Plumber watched us go, barely lifting their heads. Looked like my new horse went as well solo as he did in a group. Not all horses possessed this desirable trait. I was happier and happier with my acquisition.

When I reached the end of our short side road I cut across the neighbor's field; Sunny eyed their goat pen with a slightly askance expression, but didn't spook. I parked him alongside the main road and waited to cross.

Cars, trucks, busses whizzed by. Sunny stood, calm and quiet. I waited. And waited. A clump of fur by the white line drew my eye. Finally the traffic cleared. I kicked Sunny to a trot, looking down as we passed the small carcass.

A cat. A little tabby cat, unknown to me. Just another victim of this busy road.

The sight of the cat's smashed body, road kill like so many others, brought sudden tears to my eyes. Perhaps someone had loved this little cat; maybe only yesterday he had cuddled in the curve of a child's arm, happily purring, safe and warm. Now the spirit was rent from his body, suddenly and violently, leaving what? This carcass, certainly. Was there anything more? The

fragile little mind-body creature was gone. Did his spirit still exist somewhere, somehow?

Why? The ready question leapt to my mind. What horrible sort of thing was this life we lived, in its brevity and brutality? What was the point in our love for these little spirits housed in bodies, human or animal, if they were all to die eventually, some sooner, but all in the end, some suddenly and in pain, but all sure to become an empty, cold carcass, no longer the creature we loved?

And what happened to the one we loved? We didn't know. Was he just gone, like a candle flame snuffed out? Was love a cruel joke?

Once we could no longer touch the warm body, see the face and look in the living eyes, hear the words, hold the hand, and smell the special scent, what then? Once the spirit had left the body, was it gone entirely? The ones I had lost seemed gone. I missed them sorely. I could no longer feel their presence in my life. They were gone.

Are we really? The still, small voice in my mind was no voice I knew or could hear. It was just there.

Am I gone?

Somehow I knew it was Roey, my lively red dog.

Can you not feel me?

The tears slipped down my cheeks as I stared at the curve of Sunny's cream-colored mane springing off the crest of his smooth gold neck.

"I can feel you here," I whispered to her in my mind. "But I don't know what it means. It's just a voice in my mind. I don't know if it's real. When I hold Mac in bed, that's what's real. And that's exactly what comes to an end."

How do you know what's real? Love is just a cruel joke if death is an end to the spirit. But what if death is just a passage? What if it is a change, not an end? What if love endures?

What if? I wanted to scream. What good is what if in the face

of the overwhelming love I felt for Mac, Mac who would one day die, as would I. I had no guarantee at all that it would not be tomorrow, as Kate and her little girl had so suddenly and violently died. I had no guarantees at all.

Why was life so? Why not something tranquil, harmonious, gentle, stable? Why not something that stayed? What good God could possibly have created this brief, brutal, transitory, painful experience, spirit wedded to body for just long enough to yearn for permanence, to learn to love others who were equally impermanent? What piece of shit was this?

And then I remembered the autumn afternoon that I brought Toby the pony home from the equine center, knowing that he had a terminal diagnosis, cancer in his kidneys, and hadn't long to live. I had shut the front gate and turned him loose, and he wandered along the driveway all afternoon, grazing. Mac and I sat down next to him in the grass and the sunshine, and Toby drowsed for a while and watched us.

Mac petted him and hugged him, and said, "Can you see how much I love him?"

And I said I could.

That night Toby shut himself in his pen, closing the gate with his muzzle.

The next day he roamed the garden, grazing, and stayed in the hay barn, and as we left him, Mac stepped up to him in the most natural way and gently stroked his muzzle in goodbye, the last time he would ever pet his pony. Blue and I did the best we could; and fed Toby carrots and gave him painkillers on that last evening, and then put him down when it was clear that he was miserable.

But in that one moment, as Mac said goodbye, we were all together in truth and love and beauty—as close as I would ever come to understanding what is. Life and death and being connected. Being sad no different from being happy. Two halves of one whole. And we are part of it. Not separate, just a part of it.

"Thank you, Toby," I whispered. "I love you."

Sunny stumbled and I blinked. Somehow or other, without really seeing the terrain around me, I had managed to ride Sunny through a small grove of willows, up the hill by the boarding stable, past a few neighborhood houses, and to the bottom of the ridge trail.

The ridge trail was steep, and I seldom rode it with Mac, but I had wanted to test Sunny a little. And here we were.

Sunny looked at the sharp upward trend of the sandy trail ahead and paused. I could feel his thought. I'd rather not go up there. Maybe I won't.

I kicked him firmly in the ribs and clucked. Oh yes you will, I told him silently.

Sunny sighed and began to clamber up the ridge. I could feel his sturdy legs driving as he hopped up the first big step up, a two-and-a-half-foot shelf. As we were already scrambling up a pretty steep hill, it was quite a jump.

But my little palomino plug managed it handily. It was becoming clearer all the time that Sunny had covered a lot of country in his life. I was starting to have confidence in him.

Up the trail we climbed, Sunny taking the step-ups in stride, trotting a little in the steepest places, easing up to breathe when the trail leveled out some. As we climbed, a broad vista opened up to the west, similar to what could be seen from the Lookout. There was Monterey Bay and the headlands to the north. The air was misty today and most of the horizon looked whited out. I wondered if the fog would come in, or perhaps this was a little front that would bring rain. On we climbed, up and up.

The sandy southwest slope was carpeted with manzanita, greasewood, black sage, and monkey flower, the plants of the dry chaparral. I could smell the aromatic, spicy scents, mixing with the dust of the trail, and the horse and saddle-leather smells of my mount. I took a deep breath. Life was good.

We were on the crest now, with a big dropoff to our right.

The trail headed down the other side, descending abruptly into a forest of mixed pine, eucalyptus, and oaks. Sunny picked his way down the hill slowly and carefully, his ears forward, looking at everything.

We topped the next rise and were in the midst of a eucalyptus grove. Mac called this the "five thousand eucalyptus forest." All around me the slender pinkish trunks with their peeling bark squeaked and groaned in the slight breeze like an old wooden sailboat. Long shafts of light slanted between the airy, constantly rustling trees.

Sunny trudged purposefully as the trail followed the ridgeline up and up. I could see the spiky crown of the landmark tree to my left and the warm meadow and cold valley below me. We passed between several huge Monterey pines and descended another hill to find ourselves at the trail junction.

I rode on up the next hill, passed the trail that led to the Lookout, and started down what was arguably my favorite trail in the whole network. I called it the "pretty trail," and for me, in some way that I couldn't define, it seemed to epitomize the whole green world of the ridgetop, this familiar landscape that I loved so well.

The pretty trail sloped gently downhill between a mixed forest of oaks, redwoods, and broad-leafed trees. Wildflowers and grass fringed it and green-gold light shot through the canopy above and dappled the ground. Everything seemed to swirl around me in a leafy kaleidoscope of shimmering life. Though I couldn't see it through the branches, I knew my house sat on the ridgeline opposite. The trees that screened the pretty trail were visible from my porch. Somehow, when I was here, I always felt that I was at the heart of things, the center of my own personal green world.

I rode on, seeing Sunny's pricked, creamy-yellow ears in front of me, content in the moment, asking no questions, needing no answers. I was here.

Long minutes later, the pretty trail descended to an open

scrubby meadow, dotted with large clumps of rustling pampas grass. I reined Sunny to a stop at the trail fork. If I turned right, I would be on the trail that passed the swingset and could take me to Tucker Pond and Cole Richardson's driveway.

Did I really want to do this? I hesitated. My mind felt blank. But somehow my hand reined Sunny to the right and we trudged up the hill in the direction of the abandoned swingset. Like it or not, it seemed, I was headed to Cole's empty house.

The house obsessed me. Whether it was the strange aura I felt, or my underlying conviction that the answer to the murders lay there, I didn't know. I did know that I had a half-assed idea, one that I hadn't confided to Blue or Bret.

How do you tell your husband, or a cop, that you plan on a little breaking and entering?

Chapter 21

THE ANSWER is that you don't. Or at least I hadn't. I had told Blue where I was going. I had my cell phone in my pocket. That seemed adequate.

If I was right...if that screen door was open, I wouldn't even be breaking in. Just walking through an open door. If the caretakers weren't around, which they shouldn't be, I could take a look in that file cabinet. And maybe find out if there was something that could save Lonny.

I still wasn't sure I actually wanted to do this, though. Little bubbles of anxiety rose in my stomach as Sunny marched up the hill. I'll just see how it feels when I get there, I told myself. I'll just see.

The sky seemed to be getting grayer every moment. Wind rustled emphatically in the big clumps of pampas grass that lined this part of the trail. The air was growing rapidly colder. Either the fog or a storm was blowing in. It was hard to tell which.

Sunny trudged along, not seeming bothered by the wind that whipped through the brush and flipped his mane around. Tree branches overhead blocked out most of the sky as we plunged down into the oaks, but I could tell it was getting darker. I shiv-

ered in my denim jacket. I hadn't planned on a storm. Or the blowing fog.

On we went, uphill and down. Sunny's hoofbeats made a steady rhythm. Ahead of me the oaks opened up into a clearing. I could see the swingset, forlorn in the woods, its swings long since deteriorated, only the frame remaining. I shivered again.

Sunny walked calmly up the trail, ears forward. The wind blew the grass in long bending swells on either side of me. The trail fork was ahead. I reined Sunny to a halt by the swingset. The left-hand turn led to Tucker Pond.

I'll just go to the pond, I told myself. No harm in riding to the pond. You do that all the time.

Reluctantly, Sunny obeyed my signal to take the left-hand fork. His gait slowed as he registered that we were heading directly away from home. But he walked on obediently enough, through the purple stars and shiny green leaves of the run-amok vinca, past the ruins of the little house and barn, and through a tunnel of green shrubbery where the abandoned car rested. We dropped down a short, steep hill and Tucker Pond was before us, its water brown and wind riffled.

Also the gravel road. I pulled Sunny up by the pond and stared at the driveway. Should I go up?

That's what you came for, Gail, my mind rebutted. But I didn't feel the least bit confident.

I thought of Lonny, and his weary voice. I thought of what Bret had told me. I reined Sunny to the left and headed up the hill.

The drive wound up through the trees, first redwoods and then oaks. The wind blew. Sunny still marched steadily along, his ears forward, but I could sense a certain tension in his body. We both knew what was ahead.

A sharp neigh as we rounded the next curve announced the horse barn. Both horses stood in the corral, haltered as before,

ears forward, staring at the equine visitor. They trotted up to the fence and watched our approach. Sunny came to a halt and watched them. My eyes were on the hitching rail in front of the barn. This was where I planned to tie Sunny.

I'd prepared for this by leaving Sunny's halter on underneath his bridle and tying his lead rope around his neck. I figured he would be happy enough with the two barn horses for company and safe tied up to the very solid-looking hitching rail. Even if the caretakers, or someone else, happened along, there would be no reason for them to mess with my horse. They would just assume that some casual trail rider had stopped to visit a nearby bush. Or so I hoped.

I sat on Sunny and looked around. As before there was no sign of any human activity. The door to the small barn was padlocked shut. The horses in the corral watched me alertly. Sunny watched the horses. The wind blew my hair off my forehead in a cold gust. That was it.

I climbed off Sunny and approached the hitching rail and shook it. It felt solid as a rock. I untied Sunny's lead rope, pulled his bridle off and hung it on the saddle horn, checked his cinch to make sure it was snug, and tied him to the rail. Sunny stood quietly, his trademark demeanor, and gazed at me calmly.

I patted his shoulder. "Wait here," I said. "I'll be right back."

Three pairs of equine eyes watched me trudge up the hill.

Trees and bushes rustled and moved, leaves flickered. All the wind noise and motion was making me more nervous than I already felt. I looked up at the dark gray sky and decided it was stormy rather than foggy. Great. Just what I needed. I kept walking.

Up the hill, around two more curves. I could feel the house up there, see the openness ahead and above me. I was out of breath from the climb, buffeted by the wind. I tried to stay calm and centered. My heart was thudding. Stay alert, I told myself. Pay attention.

I walked around the last bend and came out into the open. The house was there, waiting for me. I stopped and stared. Other than the constant motion and noise of the wind, the house seemed completely still. Cold and implacable. Waiting, just waiting. No car in the drive. No sign of a human. But again, I sensed something there. The house didn't seem empty.

I swallowed. Reminded myself not to imagine things. This was not a haunted house. This was, as Blue had said, a big, empty mansion in the woods. Creepy enough, sure. But nothing more. I ran my eyes over it.

The driveway led to the garage. Next to the garage was a door. This was obviously the main entrance and was the closest to where I stood. Across what seemed like acres of decking, I could see a sliding glass door. Once again, it stood half open, with the screen pulled across. Most of the many windows on this side of the house were open, as well. I took a deep breath.

Now or never. I walked forward toward the deck. There were some stairs just to my right. I started up them. My heart was pounding hard.

It's about two o'clock, I reassured myself. The caretakers won't be here until later. Even if they came, I could just say I was a friend of Cole's and had ridden my horse over to see him. The door was open so I went inside. It would all be fine. And there wasn't any reason for anyone else to come around.

I was on the deck now. The wind swept by me. From my elevation, I could see the redwood tops bending and swaying above the brown expanse of Tucker Pond. I fixed my eyes on that screen door and walked toward it.

White curtains behind the windows fluttered in the flying air. I flinched every time they moved, but kept on. It's just the wind, I told myself. There's nothing to be afraid of. I was at the door now. I stopped and dug the cotton gloves that I used for riding on cold days out of my pocket.

I grimaced as I pulled the gloves on my hands. I had never, previous to this, seen myself as the sort of person who might need to bring gloves in order not to leave fingerprints at a crime scene. But here I was.

Gloves on, I looked up and down the deck. I peered through the screen.

"Hello," I called. My voice sounded weak and quavering, barely audible above the wind.

"Hello!" I yelled. That was better. "Anybody home?"

No answer. I put my gloved hand on the screen door, slid it open, stepped into the room, and slid it shut behind me. Now I was in the house.

I took a deep breath and looked around. A vast, almost empty room, with some sort of dark hardwood on the floor, white walls, and sparse, modern furniture, mostly black, spread in front of me. I could not see a file cabinet.

I began to walk across the room to the door on the other side. My booted feet tapped loudly on the hard floor. My heart thumped in my ears.

Focus, I told myself. Find the file cabinet. Keep looking.

I walked through a sleek, echoing kitchen with shiny black granite counter tops and white cabinets. I followed a dark hall toward what appeared to be bedrooms and bathrooms. I found I was holding my breath and gasped for air. I felt as if the house was holding its breath, too.

Eventually I found the master bedroom. A huge bed, a gray, patterned spread, a short gray carpet on the floor. Big windows looking out at the deck and the view. No file cabinet.

I walked back down the hall. The third room I tried seemed to be a study of some sort. There was a small bar with a glass-fronted liquor cupboard full of bottles. A leather-covered couch. A desk. And a black file cabinet. Bingo.

I hurried into the room, my hands almost shaking. I wanted to

get this over with. I wanted out of this dark, silent, creepy house. This house that felt as if it was watching me and waiting. Like it had a surprise in store for me. Not a nice surprise, either.

I had my gloved hands on the file cabinet now. It wasn't locked, thank God. I opened the top drawer and pulled out a manila folder at random.

Standing there, I opened it up and scanned the contents. Invoices, it looked like. Invoices from the Carson Valley saleyard. Dated last year. Indicating cattle sold. Number of cattle, amount they sold for by the pound, total amount of money. All perfectly routine. Exactly the paperwork you might expect the proprietor of an auction yard to have. Nothing mysterious. At the bottom of the invoice in my hand was a small notation in handwriting, "50% jr—$2400." I stared.

What did this mean? Was it Cole's handwriting? I thumbed through some more invoices. They were all for cattle sold at the saleyard. Most of them had a similar notation in the same handwriting at the bottom.

I had no idea what this meant. Hastily I shoved the folder back in the file cabinet and looked for another folder, one which held something that would give me a clue. But every folder I looked at was full of invoices for cattle sold. Most of the cattle appeared to be sold by "Carson Valley Land and Cattle." I had no idea who or what Carson Valley Land and Cattle amounted to.

A sudden gust of wind outside the window made me jump. I was getting edgier and edgier. I'd been here almost half an hour now by my reckoning, and hadn't learned a thing. I needed to leave. I wanted out of here. I needed to check on Sunny.

I took an invoice, typical of the ones I'd seen, and stuffed it in my pocket. Just as I shut the file cabinet drawer, I heard a sound outside.

I froze.

A growling, low-toned throb. It's just the wind, I told myself. But it sounded more like engine noise.

I stood perfectly still, listening with every fiber of my body. The noise got louder. The strong, growling noise of a diesel engine coming up the drive. Discernible even over the coming storm. I had a diesel truck myself. I knew the sound.

I flew to the window in time to catch a glimpse of a white dually pickup approaching the house. I could see nothing through its tinted windows.

Shit, oh shit.

I ran out of the room, down the hall, across the great room, to the screen door, as fast as I could propel my trembling legs. I slid the screen open, stepped out, and froze.

The truck must have parked in front of the house. I couldn't see it. I couldn't see the driver. Was he still in the truck? Approaching the house? In the house? Would he see me if I ran across the deck? What to do?

I dithered, unsure. But there was no cover here. I had to take the chance. I started off across the deck at a fast walk, trying to look nonchalant and not guilty, like a friend of Cole's who had hoped to find him home and failed to, and who was now going on her way.

That's my story, I told myself. I did not look over my shoulder. I pretended I had not heard the pickup, that I didn't know it was there.

I'm just walking back to my horse now, since Cole isn't home. I repeated the words in my mind.

My horse. Shit. The pickup had driven right by my horse. Whoever was in the pickup, probably the caretaker, knew that someone was around. He would have seen the horse.

I broke into a run, desperate to see Sunny and know he was all right. All right and still standing there waiting to take me home.

The wind whipped around me; the oak trees tossed and

groaned above me. A few scattered drops blew through the air as I pelted down the hill. I slowed as I neared the turn above the barn.

It would not work to approach a horse, any horse, even Sunny, at the dead run. The last thing I needed was to spook him into pulling back. I forced myself to walk around the bend in the drive, my eyes searching anxiously.

The bright gold shape of the little horse still stood tethered to the hitching rail where I had left him. Still saddled, still standing quietly, apparently undisturbed. I heaved a huge sigh of relief.

"Hey, Sunny," I said softly.

Both Sunny and the corralled horses had already spotted me. Both the loose horses nickered.

Damn.

"Be quiet," I hissed, knowing it would do no good. Those shrill nickers would carry above the storm. Whoever had arrived in the pickup could hear them, if he was anywhere about. And if he knew horses, he would know that they had just announced my location.

I walked up to Sunny, trying to convey a calm and confidence I did not feel. I reached the hitching rail, stepped up to the horse, patted his shoulder, untied the lead rope, pulled his head toward me, put my foot in the left stirrup, and slung myself up in the saddle. The voice cut across my motion like a knife.

"Hold on a minute."

Chapter 22

CALM, CIVIL, in charge, if a little out of breath, the man stood in the bend of the drive that led up to the house. He wore Wrangler jeans, a dark jacket, and a black ball cap. There was a half smile on his fleshy face. I recognized him instantly. Justin Roberts.

Justin Roberts. And suddenly a lot of things became obvious.

I could tell that Justin Roberts recognized me, too, and it wasn't making him happy. His tone stayed civil, but there was an edge to it.

"Haven't I met you?" he asked.

I wondered frantically what to say. There didn't seem to be much point in denying it; the man had clearly recognized me. He'd figure out from where soon enough.

"I think we've met," I said, trying not to give anything I didn't have to give.

"In Carson Valley," Justin Roberts said slowly. "At the auction yard. You were with Bret Boncantini. That deputy."

I said nothing. I wondered if I could just turn and gallop away.

Justin Roberts was watching me closely. "I'm sorry, I can't recall your name," he said. Very polite.

"I'm Gail McCarthy," I said. This was the place for me to

make up some story about why I was here at Cole's house, but I couldn't think of anything to say that would make sense. I wondered if Justin had seen me leaving the house. I decided to go with attack.

"So, what brings you over here?" I asked.

Justin studied me meditatively. His hands were in the pockets of his coat, which looked warmer than mine. He didn't seem to notice the wind rocking the trees and the scattered raindrops spattering us. He just studied me as if he were trying to figure out a puzzle.

At last he spoke. "Cole Richardson was a friend of mine," he said. "I came over to see if his caretaker is keeping the house up. Offer to pay them until the estate gets straightened out."

"I see, " I said. "That's nice of you." I tried a smile. "I was just out for a ride and came up here out of curiosity. Donna Wells told me that Cole had a house up here. Lovely spot." I forced another smile, trying to meet his eyes, trying to look bland and sincere. "I'd be better be going now, if I don't want to get rained on." And I used the halter rope to rein Sunny in a downhill direction.

"Just a minute," Justin said, and there was authority in his voice. "What were you doing in the house?"

I looked back. Justin's hands were in his pockets and he looked ever so slightly edgy. My nerves tingled.

I smiled again. "I wasn't in the house. I walked up on the deck to look at the view. Donna said it was pretty." My heart was pounding harder now. The wind whipped my hair across my face. "Good to see you again." And I kicked Sunny forward a step. But I kept my eyes fixed on Justin.

"Sorry," he said affably, "but I saw you walk out of the house." And he smiled. "What were you doing in there?"

My heart thumped loudly. I tried to return the smile. "Okay, you caught me." Make it light, Gail. "I was curious. The screen door was open. I just went inside to see what it looked like. I'm

always curious about other people's houses. I'm sorry. I didn't touch anything. Do you mind if I go now? It's about to storm."

And I asked my horse for another step down the hill, my eyes still on the man.

He watched me with a thoughtful look, very like a chess player contemplating his next move. "Just a minute," he said again.

Now or never. "Sorry," I said, "Got to go." And I asked Sunny to walk down the hill, keeping my eyes on Justin.

"Stop," he said in a quiet voice.

I saw his hand move. I knew what was coming and got ready to run.

The gloved hand came out of the pocket with a pistol in it. "Stop," he said again, and this time his voice was cold. The pistol was pointed straight at me.

I stopped.

"What the hell are you doing?" I tried to put a lot of righteous outrage into my voice.

"Asking you some questions. I'm the one that caught you breaking and entering."

"I told you why I went in the house. I did no harm. You can't pull a gun on me, for God's sake."

Justin Roberts seemed to have made up his mind. "I think you went into the house to snoop around," he said. "I think you went looking for Cole's files. I think that damn Bret Boncantini sicced you on it. And you know what, you're not going to tell him anything."

"Tell him what?" I said. "I don't know what you're talking about."

"I think you do," he said.

My mind spun. Rain spattered again, and the branches above us creaked and groaned. Should I run? He was only a hundred feet away and aiming right at me. I needed to distract him.

"All right," I said, "maybe I did look in the file cabinet. What do you think I found?"

This got his interest.

"What did you find?" he asked, and the affable, civilized tone was back in place. The gun hand never wavered, though.

"Invoices for cattle sold," I said. "Sold by the Carson Valley Land and Cattle Company. Sold through the Carson Valley saleyard. Not very exciting stuff. Bret isn't going to be very interested in that."

"Maybe." He smiled again. "Do you know the name of my ranch?"

"No," I said. "Roberts Ranch?"

"Carson Valley Land and Cattle Company," he said. "Those invoices were for cattle I sold. And if you looked closely, you'll find a little note, in Cole's handwriting, telling what percent of the money went to me."

"If you sold the cattle," I said, "wouldn't all the money go to you?"

"Not in this case. Because Cole and I were partners on those cattle. He took half and I took half."

Partners. Of course. Cole had needed a partner. A partner to buy cattle low. A partner to help rustle a few steers out of pastures at night. A partner to warehouse stolen cattle where no one would see them. I had imagined that Blake might have been the partner, but Justin Roberts was perfect. His next-door ranch could be a clearing ground for stolen cattle, out of the public eye.

"You killed them," I said. The words just seem to come out of my mouth. I felt as if the storm whipped them away, but he heard them. And he smiled.

"Cole was going to ruin me," he said. "I couldn't let that happen."

I stared at him. For a second I almost forgot the danger I was in. Instead of watching the evil little black hole at the end of the pistol's barrel, I looked blankly at the face of a man who had just admitted to murder in the same tone of voice one might use when acknowledging that he had bested a friend in a chess game.

"Why was he going to ruin you?" I asked at last.

"He wanted to break up our partnership. He wanted out. Our business was my only source of income. I couldn't let him back out." Justin's voice sounded absurdly placid as he said the words. I could barely hear him over the wind and squeaking branches above us.

"What about Lorene?" I said at last. "What had she done?"

Justin appeared to consider this. "It wasn't personal," he said at last. "I needed a scapegoat. I heard Lorene and Lonny arguing that night at Lonny's and figured he was my man. I took his gun. It worked exactly the way I planned."

"Except, Kate saw you."

Justin shook his head. "Bad luck," he said.

"So you killed her and her little girl?"

"Sometimes we have to do things we don't want to do." Justin still sounded calm and unworried. "I read her silly blog and realized that she was going to talk eventually. Lonny was out of jail and I figured John Green would suspect him. And he does. And you," he said firmly, "are not going to mess up my plans." I saw the muzzle of the gun shift ever so slightly, so that it was trained in the middle of my chest.

I swallowed. I felt icy cold and clear, despite my racing heart. I needed to keep him talking.

"Did you ride through Lonny's pasture at night?" I said, as matter-of-factly as I could manage. "I saw you, you know. From my camper. I told Bret."

Justin's half smile became, if anything, more pronounced. "You might have seen me the first time I rode through. I didn't know your camper was there. But that's not when I torched the house. I was just checking it out to make sure I had a nice simple route to ride to her place. And I did. When I came back to set the fire, I took a different line across the pasture. I knew your camper was there. You never saw me."

"Why did you ride?" I asked him.

"That ought to be obvious. I can get around that country on horseback at night like you wouldn't believe. I wear dark clothes. Nobody ever sees me. How do you think Cole and I came by those cattle?"

"I can guess," I said.

"You won't be around to keep guessing much longer," Justin said. His tone was cool. The gun barrel was steady.

"It won't work to shoot me," I said clearly. "Bret already knows what I found in this house. I've been here before. You will only tie yourself to another murder."

Justin appeared to consider this. "I don't think so," he said. He raised the gun.

"How are you going to explain a body here?" I demanded. "Better at least take me into the woods."

I watched his face, saw the point register. If he changed his focus for a second, I was going to go. I bumped my heels against Sunny's sides ever so slightly, waking the horse up. He'd stood patiently for this whole conversation, ignoring the stormy gusts of wind and spits of rain that buffeted us, waiting for my signal. Now he took an edgy step at my cue.

Justin seemed to be considering his situation. Sunny took another step. My eyes never left the man's face. I kept bumping Sunny's sides lightly.

"I was never here," Justin said steadily. "This isn't my gun. It's Cole's. Someone stole it from this house and shot you. A mystery. Not a problem for me."

He raised the gun. I opened my mouth as the wind blew its fiercest gust yet, drowning my words. The sky rumbled and a sudden crashing branch in the trees to our left made all three of us jump.

Now. I kicked Sunny with all my strength, ducked low over his neck and charged forward down the hill, not looking back. I heard the sharp crack of the pistol, and kicked harder. Go, go, go.

We were plunging down the hill through the wind and rain,

Sunny throwing me off balance as he bolted, out of control, away from the gunshot. I grabbed the horn and hung on, trying to stay low on his neck. Another shot rang out.

I could feel no impact. My horse was still moving sound. We were around the bend. I thumped furiously on Sunny's sides and he careened down the hill. We were getting away.

Chapter 23

STAYING ON was the problem. Plunging downhill at the gallop, I was slung from one side of the horse to the other like a rag doll despite my grip on the saddle horn. I made an effort to check Sunny with the lead rope, desperate to stay aboard, and felt him slow a bit. I pulled myself upright and risked a glance backward up the drive.

Nothing but trees tossing in the wind. I blinked. Still nothing. If he'd run after me, he would be in sight by now.

I slowed Sunny to a long trot, fast enough to keep moving down the hill briskly, but a lot easier to stay with. I did not want to fall off. Justin had to be coming after me. He'd incriminated himself too thoroughly. But I still didn't see him.

I was almost at the bottom of the drive. I could see Tucker Pond ahead, brown and ruffled, its reeds waving wildly. Sunny pulled hard against the lead rope, wanting to go home. Rain and wind spit at us. We were on level ground. Dropping my hand, I gave the horse slack and let him go.

In one stride we were galloping. I could hear the echoing thuds of Sunny's hoofbeats as he thundered along the trail by the pond. His ponderous, rolling gait smoothed out as he drove harder and we started up the hill.

Sunny grunted with effort, the wind whipped my face, the

ground pounded beneath me, the trees tossed and moaned above, and the storm howled. Everything seemed to be whirling around in a noisy inferno, punctuated with cold and wet. I couldn't see much. All I could hear was cacophony.

A sudden eerie white light flared; a moment later the sky boomed. Part of my mind noted that this was thunder and not gunfire. I hung on and let the horse go.

He galloped on up the hill, his breath coming harder now. A few more driving strides and we were nearing the top of the climb. I could feel Sunny easing up and used the lead rope to slow him as we dove into the tangled shrubbery, still following the trail.

Branches slapped me; I ducked low over the horse's neck. Sunny stumbled suddenly, throwing me forward. I grabbed the horn in time to avoid being flung off his back. Pulling on the lead rope, I slowed him to a trot.

"Easy," I said. "Let's get home in one piece."

Sunny was tired. He checked down easily and trotted through

the brush, breathing out long rolling snorts as he went. We passed the ruins of the Richardson house, half blotted out by vines and mist. I pulled Sunny up at the black skeleton of the swingset and could feel his flanks heaving.

"Easy," I said again. "Grab some air. We've got a ways to go."

I looked back at the trail behind us. Sunny stared, too. The oak trees tossed above the green-leafed vinca. Strange wraiths of mist twisted between the redwoods across the valley. Raindrops swirled around me in gusts. Sunny's ears went sharply forward and his head came up. And then he neighed.

For a second I didn't understand. And then I saw. Charging through the brush, coming toward us, a horse and rider. Galloping. A dark horse with a dark-clad rider.

Oh shit. He'd mounted one of the horses in the corral. He was coming after me.

I tugged on the lead rope and thumped Sunny's ribs with my legs. But the horse danced in place, his eyes on the oncoming horseman. Using the lead rope, I whipped his sides, and he leapt forward in a sudden lunge. I ducked forward over his neck and heard the sharp crack of the pistol above the storm.

Come on, come on. He was right behind me.

I didn't look back, just rode for all I was worth. We were charging up the hill between the oak trees, headed for the ridge-line. Sunny was running as hard as he could, excited by the shots and the galloping horse behind him, but he wasn't a particularly fast horse. I hoped the dark horse wasn't either.

Trees swept by, raindrops beat against my face. I could feel Sunny digging hard, grunting as he drove forward up the slope. I wasn't hearing any more shots. Nor could I hear following hoof-beats on my trail.

I risked a glance backward as we topped the ridge. He was still coming, but we'd pulled away. He was bareback with a halter; I had the advantage. I spun Sunny and headed down the hill at the long trot.

I absolutely had to stay on. If he caught me, he'd shoot me. He was chasing me against the odds because if I got away I'd ruin him. I just had to stay out front, not fall off, and make it home. I knew exactly how hard it would be for him to hit me with a pistol from the back of a moving horse. Especially with him riding bareback, especially if I were moving, too. The odds were in my favor. Unless I fell off.

As if on cue, Sunny stumbled again, and I lurched forward over his shoulder, saving myself at the last second with a grab for the horn. My heart seemed to bounce up my throat into my mouth, and I gasped for air, checking the horse with the lead rope as I pulled myself upright. My God.

I could hear crashing on the slope above me and kicked Sunny forward. I couldn't stop. He'd catch me. But I couldn't fall off either.

I need to get through this, I prayed to whatever was out there. Help me. I have to get home. I need to be there for Mac, I can't die. Mac needs me.

Rain and wind beat at me; Sunny lurched from side to side as we jolted down the trail. I knew Justin was behind me; I didn't dare take the time to look back. I kept riding, my eyes on the trail ahead, looking for obstacles, trying to stay balanced and on top of the horse, checking him as well as I could with the lead rope and halter as we came to a steep bank.

Sunny half slithered, half slid down, and we were on the trail that ran through the relatively level pampas grass meadow. I kicked the horse up to a gallop.

Sunny leaped forward just as the shot cracked out. I kicked him again as he bounded; grabbing the saddle horn, I clung on as we lunged between the big, tossing clumps of pampas grass. Through a haze of rain I recognized that we were taking the route that led to the sidehill trail, the most direct way home. Whether chosen by Sunny or myself I wasn't sure.

Sunny was bolting in earnest now. I leaned forward over his

neck and tried to stay with him. Rain lashed at my face. As we crossed the open ground in the middle of the meadow a great gust of wind broadsided us like an open-handed slap. Sunny snorted and slung his head, but didn't break stride; I gasped and tried to shake my wet hair out of my eyes. Between my hair and the blowing storm, I was half-blinded.

We were almost across the meadow now, coming to the scattered oaks on the far side. As we reached the cover of the closest trees, I risked checking Sunny for a look back. The dark horse and rider were instantly visible. Justin was galloping across the meadow, headed for me.

I spun Sunny and kicked him back to the gallop. The horse drove forward, propelled by adrenaline as much as my cue. I thanked God he was bold and strong. Despite the wild storm buffeting us and the sudden gunshots, Sunny was charging as if in the front line of a battle.

I rode. We were galloping towards the ridgeline, soon we would drop over onto the narrow trail that led through the forest. Lightning flashed, thunder rolled. Rain blew in my face; wind dinned in my ears. The world was a dark, noisy kaleidoscope, rushing around me.

We topped the ridge and I slowed Sunny to the long trot as we took the narrow, winding sidehill trail. We were in the eucalyptus now, the tall trunks groaning and creaking as they swayed above us, the crowns tossing and roaring like surf over our heads.

Swiping the water out of my eyes with one hand, I gasped as Sunny stumbled. Again I grabbed for the horn; Sunny recovered himself in one stride and trotted on, plunging down a little gully and up the other side. I kept my attention forward and rode for all I was worth. I knew Justin was back there, but I also knew that I could go faster than he could. Riding bareback at the gallop with a pistol in one hand would be difficult at the best of times and riding a strange horse in a rainstorm was hardly the best of times.

It was dark under the trees, but the wind and rain were less.

Sunny trotted on the downhill slopes and loped on the rises. The brush and trees were thick and tangled around us and I felt a little safer. Justin could hardly see to shoot me here.

I tried to stay balanced and forward on Sunny, where he could most easily carry me. I could tell he was getting tired, steam rose from his coat and his flanks heaved under me, but he didn't seem to be weakening.

Whack! My knee exploded in a sudden blast. I gasped with pain and lurched sideways in the saddle. Not shot, I realized; I'd collided with a very solid trunk that leaned into the trail. I gritted my teeth and rode on.

Ahead was the branch that Mac and I called the head-bonker. I needed to stay focused; I needed not to miss my duck. That tree would knock me off, if not knock me out. I couldn't fail here. We were getting near the road. I'd be safe soon.

My knee screamed a protest, but I ignored it. I kept Sunny in the trot. I didn't look back. I just needed to get through this last bit of woods. There was the low, solid branch ahead. I'd never gone under it at any gait but the walk. I didn't dare slow down now.

I took a deep breath and threw myself forward, flat on Sunny's neck, grabbing his long mane for support. I prayed he wouldn't stumble, wouldn't take this opportunity to dump me. I clung to him like a burr and kept my head down.

Wet leaves brushed me; I pulled myself upright. The branch was behind me. I couldn't see the pursuit. But I could hear him. He was coming. I clucked to Sunny and we half trotted, half slid down the steep hill and then loped through the shrieking, waving eucalyptus trees, Sunny popping over the downed branches in our path. One more steep little slither downhill, and I could see the road ahead of me. The whiz of car tires on wet pavement was audible over the storm. I could see the vehicles rushing by beyond the trees. Sunny was pulling hard; he knew he was near home.

We galloped across the meadow and I used all my strength to pull Sunny up in the oak grove. The road was ahead. It would achieve nothing to escape Justin only to be hit by a car.

I struggled to control my fractious, prancing horse with just a halter, as I stood at the shoulder of the road, peering desperately into the rain, seeking a clearing to cross in. I'm safe, I told myself. I'm safe. He can't shoot me here, with all these cars and people.

But I wasn't sure. The cars were blasting by on the wet road, no one was really watching me. I could hear the horse coming, crashing through the trees and down across the meadow. I had to cross, I had to.

I strained to see through the rain. It looked clear. I couldn't see a car. I kicked Sunny and he jumped forward, his hooves slipping a bit on the wet pavement as he scrambled into a lope. I grabbed the horn and tried to steady his head. He stayed up and we loped across the road and up the hill on the other side. I pulled him up behind a big Monterey pine and looked back.

Through the flying sheets of rain I could see the dark horse with the dark-clad rider reach the other side of the road. The horse was galloping, clearly out of control; the man was aboard, but barely. He seemed to have lost his hat and it looked as if there was bright red blood on his forehead. Perhaps the head-bonker tree had claimed a victim. Neither mount nor rider made the slightest effort to check as they reached the road; the horse never even broke stride as he charged out into the oncoming traffic.

I heard the scream of tires on pavement; what seemed like long seconds later but was just a moment, I heard the loud heavy thud and crash of breaking glass. The car struck the horse and rider straight on and slid to a stop on the verge. Everything was moving in a wild blur. For a second I couldn't see the horse and then I could.

The dark horse lay absolutely still, right in the middle of the road, a sad, sodden heap. I knew in an instant that he was dead. About the rider I wasn't so sure. He'd been thrown many feet

from the horse and his body, too, lay still on the wet pavement. Cars came to a sliding stop around them. Tires squealed, people emerged from vehicles and waved jackets for flags at oncoming traffic. No one noticed me on the hill behind the tree.

I stared down at the street. People gathered around Justin Roberts. Other people helped the driver of the car that had struck the horse. Someone placed a blanket over the horse's body. No one ever looked my way.

Slowly, I turned Sunny and let my sweaty, anxious horse make his way up the hill toward home. I kept in the trees and looked back over my shoulder. As far as I could tell, no one down below saw me. I patted Sunny's neck.

"Let's go home," I said.

It was done.

Chapter 24

ONE WEEK later, Bret and Lonny sat on our front porch, watching the evening sun light up the ridge across the road. The landmark tree glowed, a golden antler silhouetted against a dark background of pines. Blue raised a margarita glass and held it up.

"Here's to you, Stormy," he said.

Bret and Lonny raised their glasses and smiled. I followed suit after a moment.

"Here's to the ridge," I said, my eyes on that faraway entity. In this quiet, peaceful moment, it was hard to comprehend that I'd galloped desperately across that same ridge, riding for my life to escape a merciless pursuit. It seemed unbelievable, unreal. My knee still ached, but otherwise life was back to normal.

I stared down the hill to where my little boy was pumping in his swing hung from the big liveoak by the barn. Back and forth, back and forth, in the long, slanted evening light. Somehow the sight reminded me of the ghostly child I'd imagined on the abandoned swingset in the woods. Cole Richardson's father.

To my relief, Mac had not needed to know about my wild ride, nor that Justin Roberts and his stolen horse had died on the road in front of our property. I had managed to keep that drama from my child, thankfully.

I'd arrived home that evening drenched and shaking to find Mac and Blue happy and eager to tell me about their day at the Boardwalk. I'd hidden my distress as well as I could, attributing it to being caught in the storm and banging my knee on a tree trunk, and we'd all ignored the emergency vehicle sirens that we heard down on the street. It was a common enough sound on the busy road.

Only when Mac was safely occupied had I whispered to Blue a quick summary of what had happened and ducked into the bedroom to call Bret. We'd talked for an hour and at the end of that time Bret had a plan.

"Thank God you managed to talk that detective into driving over here with a search warrant," I said to Bret, taking a long swallow of my drink.

"Thanks to you," Bret said. "I told John Green I'd had a reliable tip that Justin had been killed in a car wreck over here, trying to destroy the evidence that tied him to Cole's murder. And it took me a while, but I convinced him we needed to search Cole's house on the coast. After that, everything fell into place."

"Thank God," Lonny said quietly.

I smiled at him sympathetically.

"So, does everyone in Carson Valley believe Justin was the murderer?" I asked.

"Oh yeah," Bret said. "It all makes a lot more sense than the idea that Lonny killed Lorene out of jealousy. Nobody ever really believed that."

Lonny shook his head.

"But Justin, now," Bret went on, "when he moved into that country ten years ago, he was a city boy with no source of income. He bought a lousy hundred acres and thought he could make a living as a cattle rancher. It was just dumb. He didn't have enough land or experience to make any kind of a living. But he was real attached to the idea of being a cowboy.

"Judging by the paperwork in that file cabinet, Cole took

Justin under his wing shortly after Justin bought that little ranch next door to the saleyard, and in no time at all the two of them were making money in half a dozen ways, all at the expense of the local ranchers. Cole had more money than he knew what to do with, and built this fancy house on the coast. Justin was making a living as a cattle rancher, which is something that meant a lot to him, apparently. I guess he didn't care that he was really a cattle rustler. And this went on for ten years.

"Justin got real good at moving around that country on horseback at night, stealing one or two head out of some rancher's big field. Nobody ever noticed. He'd keep them at his place awhile, rebrand them, and then run them through the sale. He was careful to steal solid black cattle, judging by the paperwork. Hard to tell them apart. Cole was friends with the brand inspector, and told Joe that Justin was all right, and Joe could ignore the secondary brands. And that's the way things work in a small town. Joe took Cole's word for it.

"Cole and Justin worked the sale together, with Cole selling Justin cattle at a slightly lower price. Justin would bring the same cattle back the next week and Cole would sell them at market value.

"And then Cole would tell a rancher a calf had died at the sale or a truck held one less steer than was actually on it. He'd tell Blake these 'spares' belonged to Justin and Justin would come over and collect them, rebrand them, and then he'd sell them and he and Cole would split the profit. They split all profits fifty-fifty. It was all there in that file cabinet."

"Blake never knew?" Blue asked.

"If he did, he turned a blind eye to it. He's pretty torn up now, finding out that the guy who was helping him keep the sale going is the one who murdered his brother."

"Why exactly did Justin decide he had to kill Cole?" Lonny asked. "It seems like a stupid thing to do."

"Well, it wasn't very smart. Cole was getting ready to marry

Donna Wells, the biggest landowner in Carson Valley. He really didn't need the money anymore. And I think he felt pretty sure that Donna would ditch him if she ever found out that he'd been stealing cattle in various ways. Hell, he'd probably stolen cattle from her. Cole knew if he was going to marry Donna he had to quit working with Justin.

"Here's where it gets to be guesswork. From what Gail heard, Justin didn't want to fold their little business. It was how he made his living. He knew perfectly well he didn't have enough land to be a legitimate rancher. And he loved his cowboy life. And maybe all those years of successfully stealing cattle and getting away with it went to his head. He just figured he could do anything and not get caught."

"That's kind of how he struck me," I said. "He acted like this was all a game, that he could shoot me and just go on with life as usual. He didn't seem worried about being caught."

"So Justin found a guy named Dave Allen, who was an unemployed auctioneer living in Fresno, and this guy was willing to go on with the scam. Dave Allen has already been questioned, and apparently Justin proposed the idea to him pretty directly, said he could get him a berth at the saleyard. And that's just what he was in the process of doing. Blake was grateful that Justin was helping him, as he was in over his head trying to keep the business going after Cole and Lorene were murdered. Blake thought of Justin as his brother's friend. It was all playing out just as Justin had planned."

"Except for Kate," I said.

"Yeah, except for Kate. Justin had seen Kate out in the pens, apparently, that evening he killed Cole and Lorene. He was worried that Kate might have seen him. And it turns out she did. What she said on her blog was just that she had seen someone going in the office, she'd only seen him from the rear, she wasn't sure who it was, she hadn't thought anything of it at the moment. But as time went on and she realized that she was sure

it hadn't been Lonny, I think she might have started wondering who it could have been. She never did name Justin that I know of, but he read her blog, too, and thought that she might. And he already had a plan. He'd ridden over there at night and checked out the lay of the land the day after the murders. Now that Lonny was home and could possibly be accused of the crime and Kate seemed closer to talking, Justin figured the time was right. And he torched the house. We've found a can at his place with some gasoline in the bottom of it and his fingerprints on it. It's the right size to fit in a saddle bag. We think that's what he used."

"He killed that little girl," I said, my eyes on Mac's sunlit, swinging figure. "That's what got to me. For no reason, really. She was just in the way. And when I accused him of it he smiled. He said that 'sometimes we have to do things we don't want to do.' Like it was no big deal. Right then I realized that he didn't see people in the same way the rest of us do. He saw them as chess pieces in his own game. I think in a way he was crazy. It may sound weird, but I didn't feel any sorrow when I saw him lying there on the road. I actually hoped he was dead. I didn't think he deserved to live. The horse now, I felt bad about that."

"You didn't mean for that to happen," Blue pointed out.

"No, that's true. I had no idea it might happen. I wasn't thinking of it. I hoped the head-bonker tree would knock Justin off his horse, but it didn't. It looked like he got whacked pretty hard and was maybe disoriented. But I never thought of him getting hit on the road. That poor horse. At least it was quick. The horse didn't suffer. I saw that. And the world is better off without Justin Roberts."

"Amen," Bret said.

Lonny and Blue raised their glasses. We all drank.

My eyes were on Mac, swinging high through the branches. Sunny stood on the other side of the fence, as close as he could get to the flying child, watching Mac intently. I smiled.

Lonny followed my gaze down the hill. "Do you like your little yellow horse?" he asked.

"You bet," I said.

"Are you going to keep him?"

"Yep. He took care of me. I'm going to take care of him. Sunny's got a home."

"That's good," Lonny said, and smiled.

The sun was getting lower; the light was fading from the ridgetop. I could no longer pick out the landmark tree in the gathering gloom. Mac came skipping up the hill from the barn and eyed the adults on the porch.

"I'm hungry," he said. "When's dinner?"

"Coming right up," Blue said. "I'll put the steaks on the barbecue now."

Blue went back into the house and Mac trotted up the stairs and onto the porch. He patted Freckles' head and studied Bret's and Lonny's faces. Then he leaned against me, half in my lap, half not.

"How's Gunner?" Mac asked Lonny. "Is he okay?"

"He's doing great," Lonny said. "I saw him this morning, and I'll see him tomorrow. Gunner and Danny and Twister are all just fine. And so am I." And Lonny turned to smile at me. "Thanks, Gail," he said.

I smiled back. "You're welcome."

I lifted my glass to the ridge, a dark silhouette against a peacock green sky.

"Thank you," I said.

And a little breeze touched my face.

Epilogue

MAC AND BLUE and I still ride the trails that lead to the Lookout. Sometimes we take the fork that goes past the abandoned swingset and Tucker Pond, through the old orchard and down to the redwood grove in the valley. But never again have I gone up the road to Cole Richardson's house. I don't know what happened to the place.

We go back to Lonny's ranch in Carson Valley often, to see Gunner, Danny, and Twister. We camp by the creek in all seasons, swim and ride, visit with Lonny and Bret. But by unspoken agreement we avoid the far side of the pasture, where the charred ruins of Kate's house can still be seen.

As for me, I give thanks every day for Mac and Blue, our horses, dogs, cats, and other critters, my home and garden and the hills where I live. Most of all, I try to be aware of how happy I am in the present moment. Because the present moment is what we have. We who are all going, gone.

May love remain.

Shmuel Thaler

ABOUT THE AUTHOR

Laura Crum (pictured on Sunny), a fourth-generation Santa Cruz County resident, has owned and trained horses for over thirty years. She lives and gardens in the hills near California's Monterey Bay with her husband, son, and a large menagerie of horses, dogs, cats, and chickens. She may be e-mailed and visited at www.lauracrum.com.

MORE MYSTERIES
FROM PERSEVERANCE PRESS
💀 *For the New Golden Age* 💀

JON L. BREEN
Eye of God
ISBN 978-1-880284-89-6

TAFFY CANNON
ROXANNE PRESCOTT SERIES
Guns and Roses
*Agatha and Macavity Award
nominee, Best Novel*
ISBN 978-1-880284-34-6

Blood Matters
ISBN 978-1-880284-86-5

Open Season on Lawyers
ISBN 978-1-880284-51-3

Paradise Lost
ISBN 978-1-880284-80-3

LAURA CRUM
GAIL McCARTHY SERIES
Moonblind
ISBN 978-1-880284-90-2

Chasing Cans
ISBN 978-1-880284-94-0

Going, Gone
ISBN 978-1-880284-98-8

JEANNE M. DAMS
HILDA JOHANSSON SERIES
Crimson Snow
ISBN 978-1-880284-79-7

Indigo Christmas
ISBN 978-1-880284-95-7

JANET DAWSON
JERI HOWARD SERIES
Bit Player *(forthcoming)*
ISBN 978-1-56474-494-4

KATHY LYNN EMERSON
LADY APPLETON SERIES
**Face Down Below
the Banqueting House**
ISBN 978-1-880284-71-1

**Face Down Beside
St. Anne's Well**
ISBN 978-1-880284-82-7

Face Down O'er the Border
ISBN 978-1-880284-91-9

ELAINE FLINN
MOLLY DOYLE SERIES
Deadly Vintage
ISBN 978-1-880284-87-2

HAL GLATZER
KATY GREEN SERIES
Too Dead To Swing
ISBN 978-1-880284-53-7

A Fugue in Hell's Kitchen
ISBN 978-1-880284-70-4

The Last Full Measure
ISBN 978-1-880284-84-1

WENDY HORNSBY
MAGGIE MACGOWEN SERIES
In the Guise of Mercy
ISBN 978-1-56474-482-1

The Paramour's Daughter
(forthcoming)
ISBN 978-1-56474-496-8

DIANA KILLIAN
POETIC DEATH SERIES
Docketful of Poesy
ISBN 978-1-880284-97-1

JANET LAPIERRE
PORT SILVA SERIES
Baby Mine
ISBN 978-1-880284-32-2

Keepers
*Shamus Award nominee,
Best Paperback Original*
ISBN 978-1-880284-44-5

Death Duties
ISBN 978-1-880284-74-2

Family Business
ISBN 978-1-880284-85-8

Run a Crooked Mile
ISBN 978-1-880284-88-9

HAILEY LIND
ART LOVER'S SERIES
Arsenic and Old Paint
(forthcoming)
ISBN 978-1-56474-490-6

**Available from your local bookstore or from
Perseverance Press/John Daniel & Co. at (800) 662-8351
or www.danielpublishing.com/perseverance.**